DRAWING DRAGONS

JIM HANSEN ◈ JOHN BURNS

Capella

This edition
published in 2008 by
Arcturus Publishing Limited
26/27 Bickels Yard, 151–153
Bermondsey Street,
London SE1 3HA

Author & Illustrator:
Jim Hansen

Colourist:
John Burns

Jacket design & Art editor:
Steve Flight

Layout:
Zoe Mellors

Editor:
Rebecca Gerlings

ISBN-: 978-1-84193-731-1

Contents

◈ ◈ ◈

Introduction

Of all the mythical creatures created by humankind's fertile imagination there is none comparable to the dragon. Throughout the world, dragons appear in the storytelling, folklore, literature and architecture of numerous cultures. In their various manifestations they are both benevolent and the epitome of absolute evil.

Dragons evolved essentially from the ancient snake or serpent, though the latter in evolutionary terms is now far removed from the former. Serpents cannot breathe fire or fly, though most dragons can. Serpents are found in the sea, whereas dragons are usually found inland, or flying over it, the exception to this rule being the Eastern dragons who are equated with water.

Eastern dragons are essentially benevolent and, in ancient beliefs, played a part in humankind's creation. The Chinese dragon is perhaps the most kindly and helpful dragon of all. Spring in China is the season for 'dragon processions', held to welcome their return from a winter spent underground. Chinese, or *Lung*, dragons are seen as the ultimate symbol of good fortune by the Chinese, and are often depicted clutching a large pearl or egg, which is thought to represent universal constancy.

In the West, dragons are perceived to be the ultimate nightmare; the epitome of evil that has plagued humankind since the Dark Ages, the complete manifest-ation of all that is wicked, (though our fear of them is mingled with a respectful awe). With fiery breath, sharp claws, formidable teeth – not to mention the ability to repel man's primitive weaponry – and the freedom afforded to them by flight, these magnificent creatures have always demanded our humble respect.

So, whatever fires your imagination – be it the the beautiful, serpentine Eastern dragons, with their culturally rich, Far-Eastern ancestry, or the Western dragon with its fearsome reputation, famed for its hunger for human flesh and its greedy guardianship of caverns of gold – have fun and enjoy drawing the impressive array of beasts in this book.

Tools of the Trade

The success of your work is largely down to the quality of your tools so, to get the best out of your drawing, you'll need to gather together the items listed below – all are invaluable in their own right, though you may find you'll use some more than others.

A good-drawing board:
with adjustable heights

Pencils:
Hard and soft leads

A compass pencil and pen:
Those perfect circles don't draw themselves!

Pens:
Dip pen with a fine point and felt-tip pens of varying thicknesses

Paintbrush

Lightbox:
This may not be essential – bright sunlight through a window works the same way

Set square:
Good for right angles and perspective

Hairdryer:
to speed up work

India ink:
Any good brand is fine

Jar of bleed-proof white paint

French curves:
Constantly in use

Drawing pad:
Must be good-quality paper

Ruler

Erasers

Basic Construction

Creating an image is a bit like building a house: foundations are laid down first, then the framework is created and, finally, the small details are added to complete the finished article. Once you master using the basic tools, you're halfway to 'building' your image.

All you really need to do is use these geometrical objects as the foundations to your creations. When you draw these shapes, visualize them as solid objects. You'll find shading helps to instantly give the objects a sense of depth and mass.

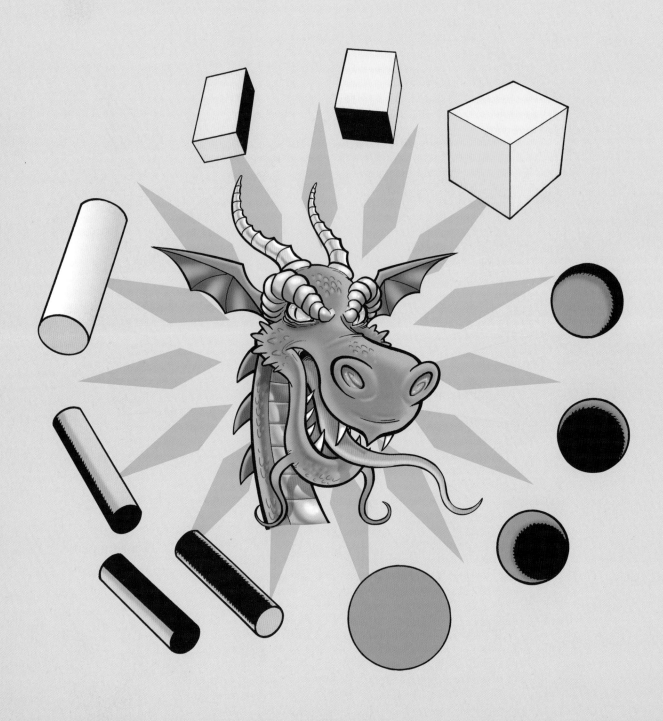

Basic Perspective

If you turn cube **A** so it's facing you flat-on, you'll see that the two side lines on top look as though they're coming together, or converging, as in cube **B**. They eventually do so, as in cube **C** if these lines are continued, and the point at which they meet is the natural horizon line.

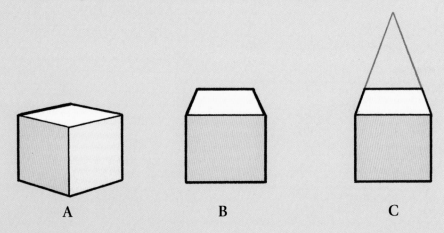

A B C

If we turn the cube back to its original position and follow the converging lines in each direction to their meeting points – as in cube **D** – we now have a two-point perspective. This cube is below eye level, as it's positioned below the natural horizon line, which enables us to see the top of it.

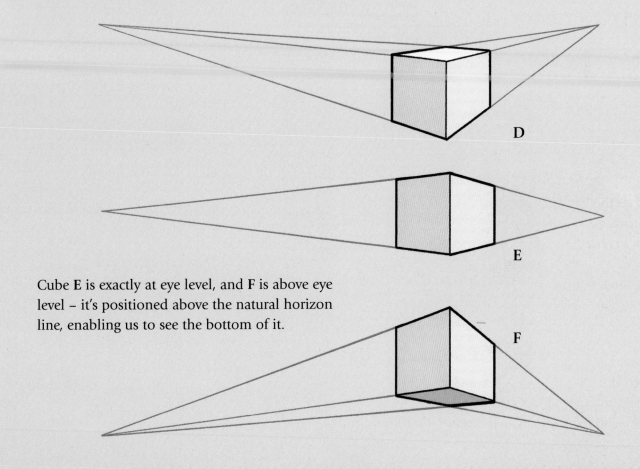

D

E

Cube **E** is exactly at eye level, and **F** is above eye level – it's positioned above the natural horizon line, enabling us to see the bottom of it.

F

Horizon Line and Line of Sight

In all art, whether it's realistic painting or visual storytelling – for example, in graphic novels – perspective is absolutely essential.

The horizon line is the very foundation of perspective. It's the line that appears as you look out into the distant horizon. It's the dividing line between the land and the sky. The line is always there even though it is often obscured by objects, light or heat.

The line of sight is the imaginary line that starts from the spectator point and travels into infinity.

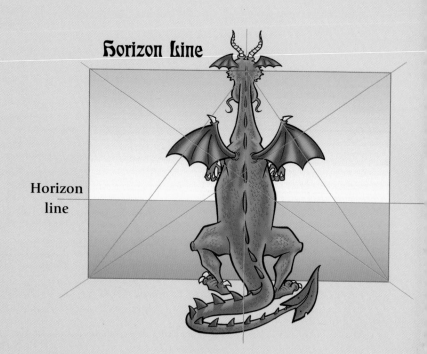

Horizon Line

Horizon line

Line of Sight

Horizon line:
This is the imaginary line that separates sky and land.

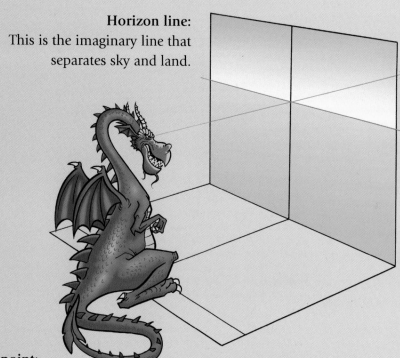

Centre point:
This is the point where the spectator's line of sight crosses the horizon line of the picture window.

Land level:
This horizontal line separates the picture window and ground level.

Spectator point:
This is the spot on the ground where the viewer stands and from which the line of sight begins – to infinity and beyond!

Distance and Forced Perspective

The picture below is an example of the correlation between objects in the foreground, middleground and background, and of inking. Three distinct line weights are deployed to give the impression of distance. Can you spot where the horizontal line is?

Distance

1. A very heavy line is used for the foreground (objects closest to the spectator).

2. An average-weight line is used for the middleground (objects a bit further away).

3. Quite a fine line is used for the background (objects in the far distance).

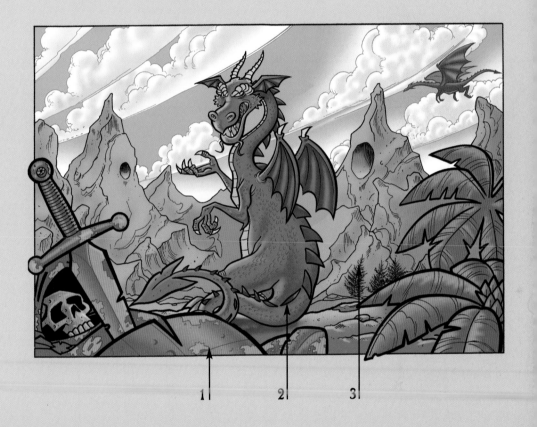

This illustration is an example of how the horizon line doesn't always have to be er … horizontal – otherwise known as forced perspective.

Forced Perspective

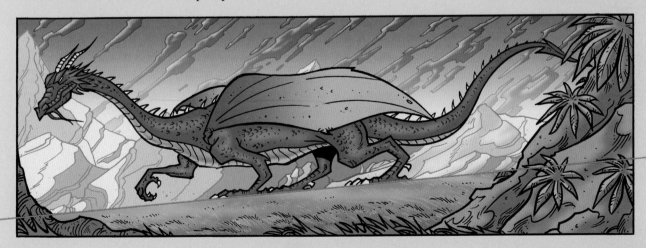

Vanishing Point

Here's an example of one-point perspective in an illustration. It's the most basic form of drawn perspective, where all the parallel lines retreating from the spectator point converge at a single point. This spot is known as the vanishing point.

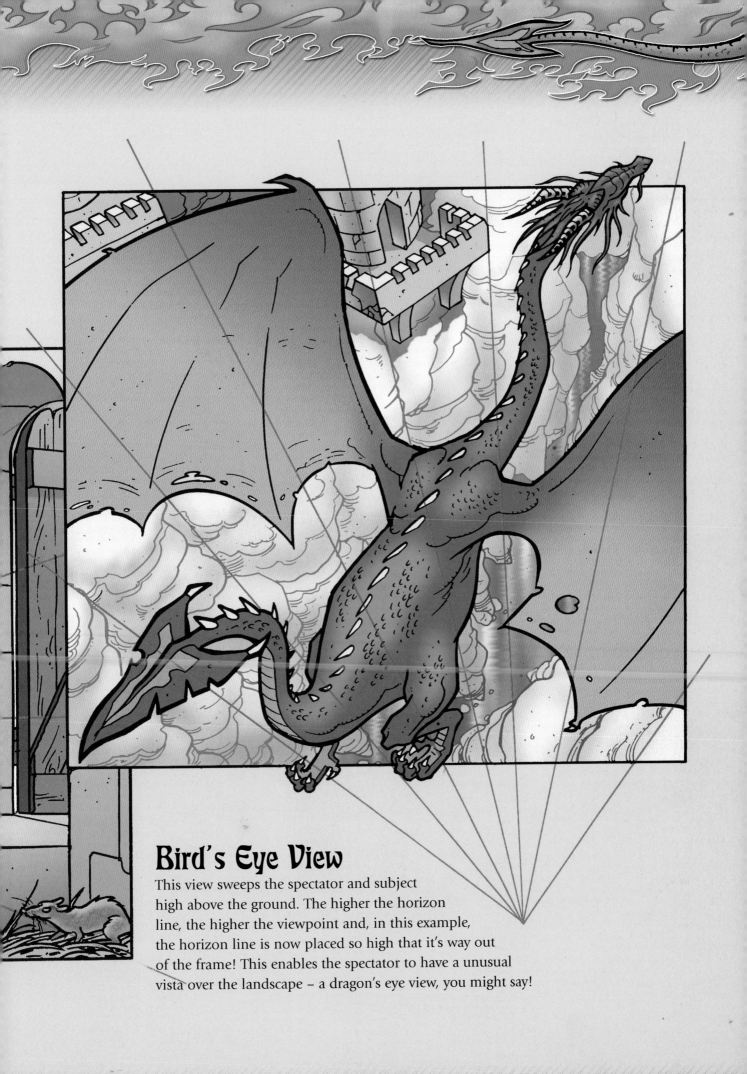

Bird's Eye View

This view sweeps the spectator and subject
high above the ground. The higher the horizon
line, the higher the viewpoint and, in this example,
the horizon line is now placed so high that it's way out
of the frame! This enables the spectator to have a unusual
vista over the landscape – a dragon's eye view, you might say!

Worm's Eye View

In contrast to the bird's eye view, the worm's eye view takes the spectator point right down to ground level, or even below, so the viewpoint is at the same level or below the horizon line. This gives the subject a dramatic, imposing feel, as befits a fearsome dragon like this one!

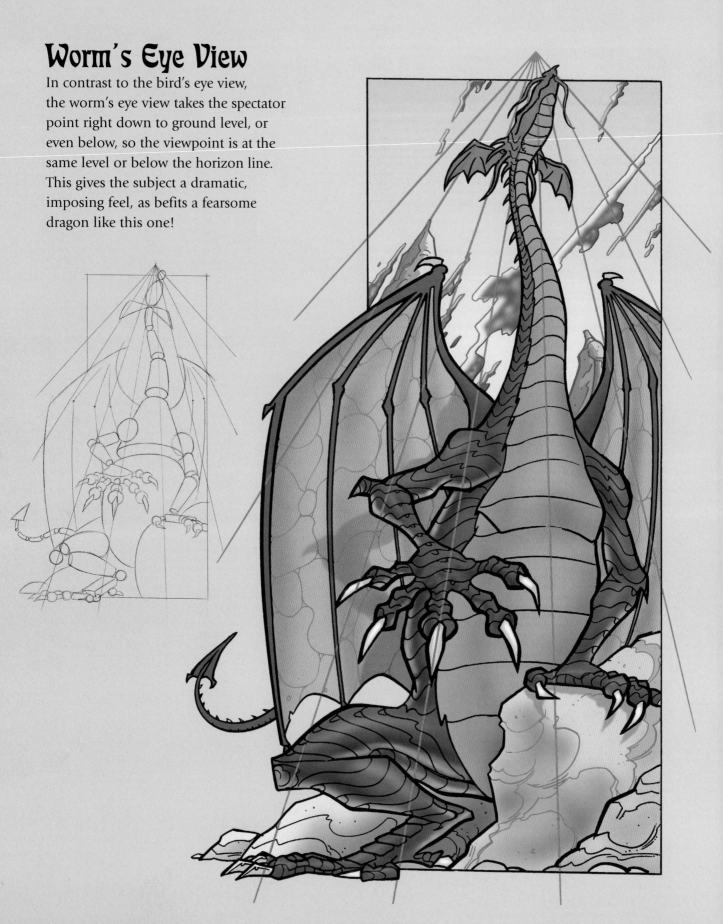

Foreshortening

When you look at an object or figure it's hardly ever in flat perspective; there's usually some part of the object that is bent away from you or tilted towards you, or angled in some manner. Try taking a simple cardboard tube and holding it straight up in front of you. Tilt it slowly forward and, as you do, you'll see it shorten.

Horizon line

Horizon line

The top illustration shows a body coming towards you, and was constructed with the aid of the different-shaped building blocks mentioned earlier.

The one below it is the reverse, with a body disappearing off into the distance. All the lines converge to the vanishing point.

Eyes

> *Now it's time to focus on drawing the details before we move on to the main attraction.*

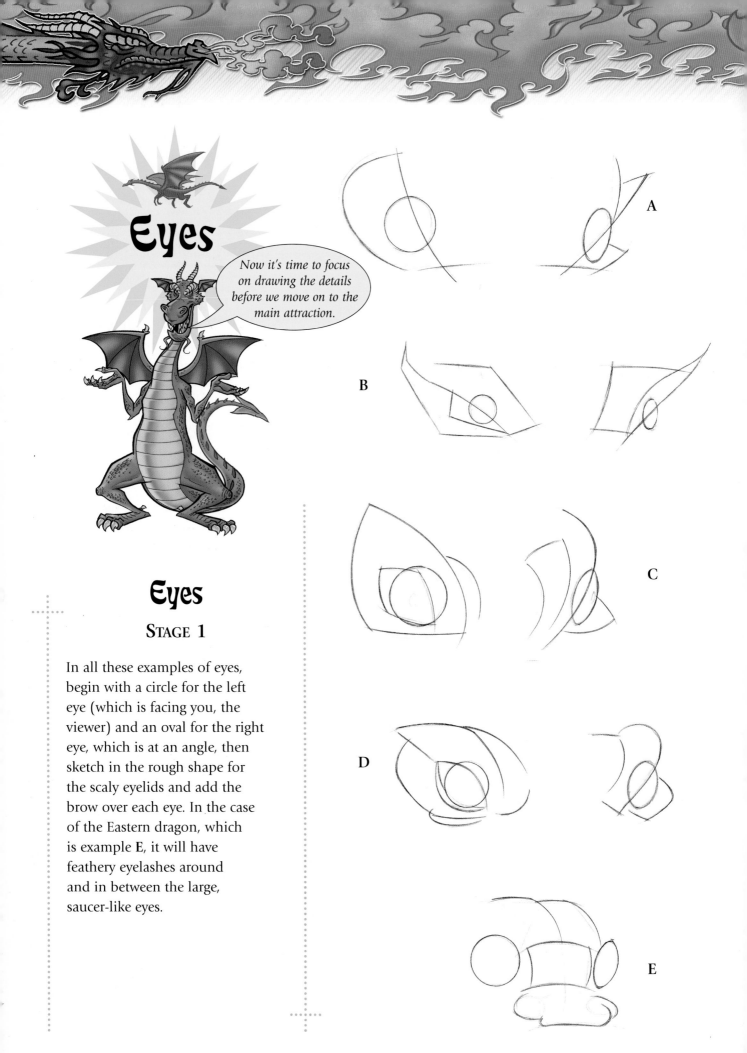

A

B

C

D

E

Eyes

STAGE 1

In all these examples of eyes, begin with a circle for the left eye (which is facing you, the viewer) and an oval for the right eye, which is at an angle, then sketch in the rough shape for the scaly eyelids and add the brow over each eye. In the case of the Eastern dragon, which is example **E**, it will have feathery eyelashes around and in between the large, saucer-like eyes.

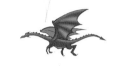

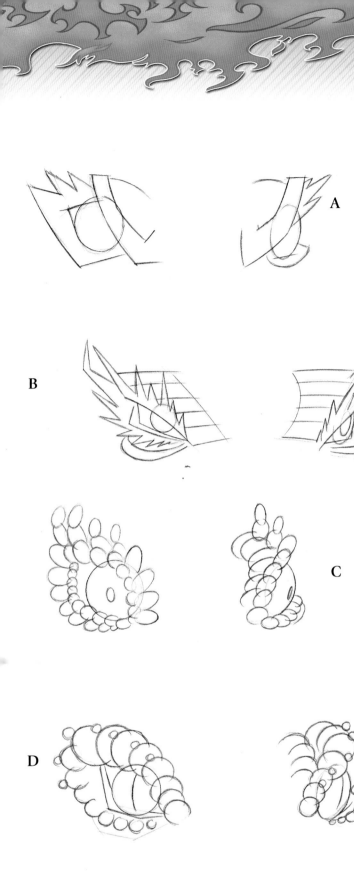

Eyes
STAGE 2

A

Shape the eyelid scales and sketch in the small horn growth in front of the eyes.

B

Draw horizontal lines above each eye.

C and D

Sketch in a variation of shapes and sizes of ovals and circles around the eyes. A slit represents the pupil.

E

Work out the design for the 'eyelashes' and pencil in the four 'forehead' bumps.

Next, start to build up the beginning of the individual eye designs…

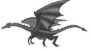

Eyes

STAGE 3

A

Add the 'lumpy' scaling on the forehead and define the spiky eyelids more.

B

Using quite sharp, angular lines shape the eyelids a bit more.

C

Build up the scaly lids; smaller ones around the eyes, larger ones above.

D

This is shaping up to be quite crocodilian in design. The eyelid scales now become triangular.

E

Lightly sketch in the highlights reflected in the eyes and mark in the individual lashes around and between the eyes.

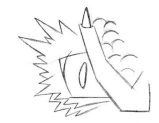

A

B

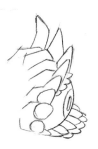

C

D

E

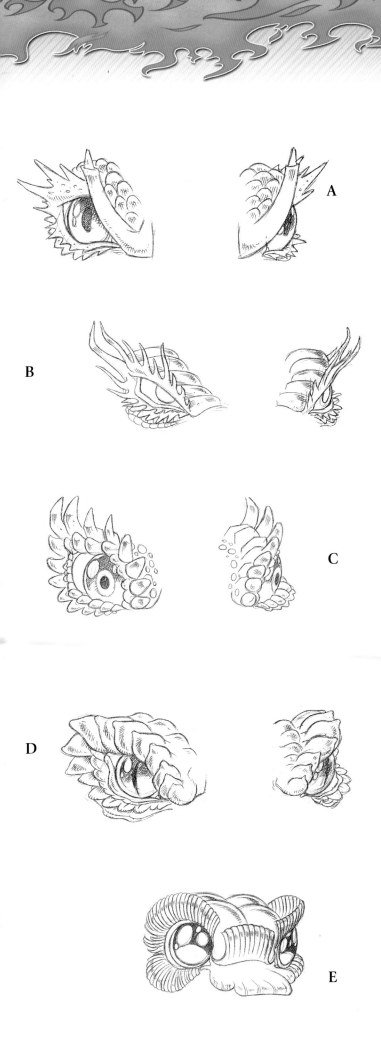

A

B

C

D

E

Eyes

STAGE 4

The eyes are really beginning to take shape nicely now. Add the pupils and smooth out the angular lines. Then carefully finish off your pencil sketches by adding the shading, giving greater depth to your drawings.

A

Indicate the shine in the eyes to give your drawing more of a three-dimensional feel.

B

Add highlights to the scales around the eyes.

C

Draw in the light reflected in the eyes and shade the scaly eyelids, including the small nodules on the forehead.

D

Now they're fully shaded too, these eyes have a particularly menacing stare. Very cold and calculating…

E

Add the shine to the fringes around this Eastern Asian dragon's eyes. These feathery hairs are as fine as silk.

Eyes

STAGE 5

A, B, C, D, E and F
With a dip pen, felt-tip pen or brush, go over your pencil drawing with a bold line, choosing a thinner point for the finer details.

◇

STAGE 6 *(opposite)*

A
Grey scales and horned growths protect this calculating pair of yellow eyes.

B
These bright red eyes fringed by leathery orange eyelashes look like they've got some prey in their sights.

C
Horny eyelid scales shade the red-veined eyes and their small, black pupils.

D
The crocodilian-like scales around the dragon's eyes are a vivid green. The pupils are just slits in these evil eyes.

E
Golden, feathery eyelashes circle the large liquid-blue eyes of this Chinese dragon's head.

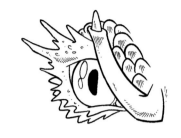

A

B

C

D

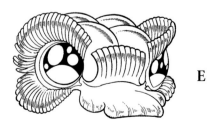

E

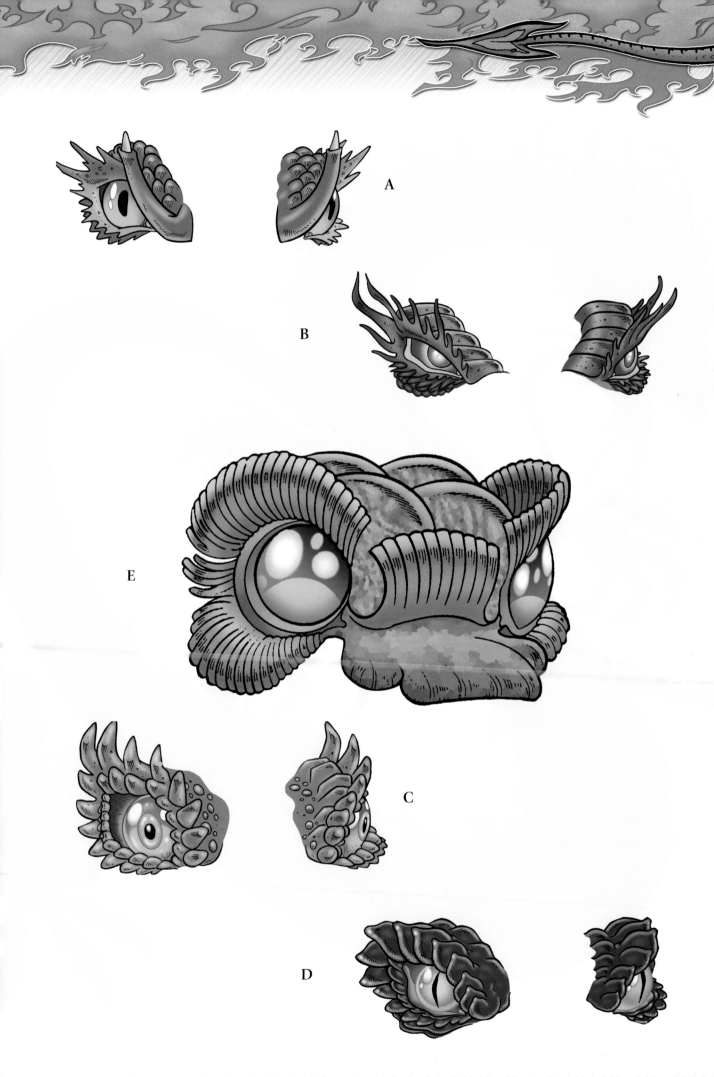

A

B

E

C

D

Claws: Hands

Claws: Hands

STAGE 1

Dragons' hands – or talons – are extremely strong and, with their vicious, diamond-hard claws, make formidable weapons.

A, B, C and D
First, decide the angle of the hand required and draw an oval to suit. Place little circles where the knuckle joints are and join them with single lines, which will give you the rough layout of the hand.

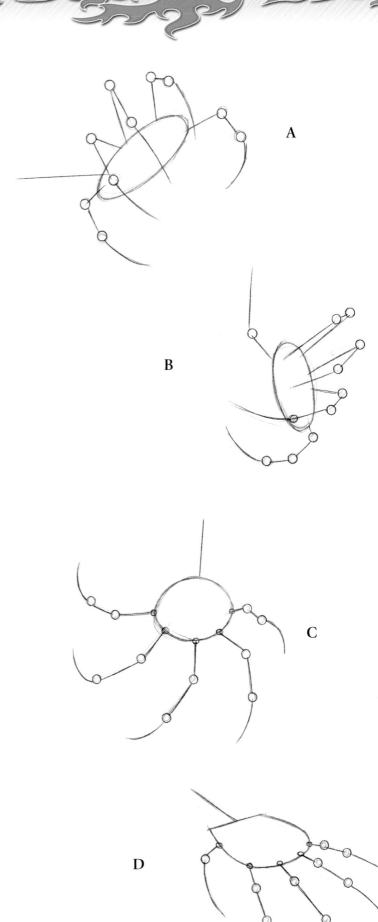

A

B

C

D

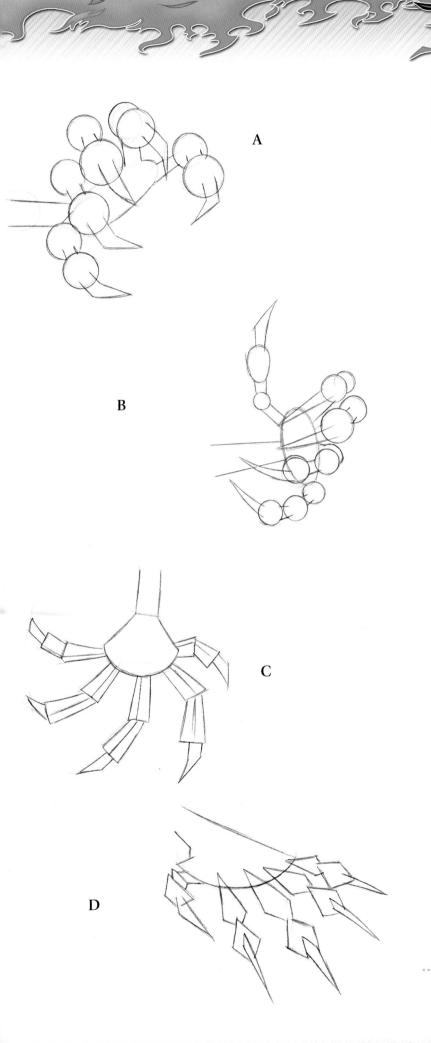

A

B

C

D

Claws: Hands

STAGE 2

A and B

In these examples, enlarge the circles to the full size of the knuckles and join them with double lines the width of the fingers. Give **A** hooked claws and **B** long talons.

C and D

These hands are constructed differently. Use blocks for **C** as the knuckles aren't quite as large and knobbly. In **D**, try two diamond shapes for each finger, and three for the thumb. Now add claws to both examples.

Claws: Hands

STAGE 3

Now start to define the overall shape of each hand then add all the fine detail, indicating the shading on the claws, building up the ridges on the knuckles and adding the scales.

A

This hand is particularly lumpy and 'horny' – a cruel, vicious-looking hand.

B

The knuckles of this hand aren't quite as knobbly as **A**, and the overall hand is slightly more elegant (if that's possible!).

C and D

Build these up into recognizable hands or talons. Remember, the middle finger is always the longest. The different species represented here all have four fingers, but some Eastern dragons only have three.

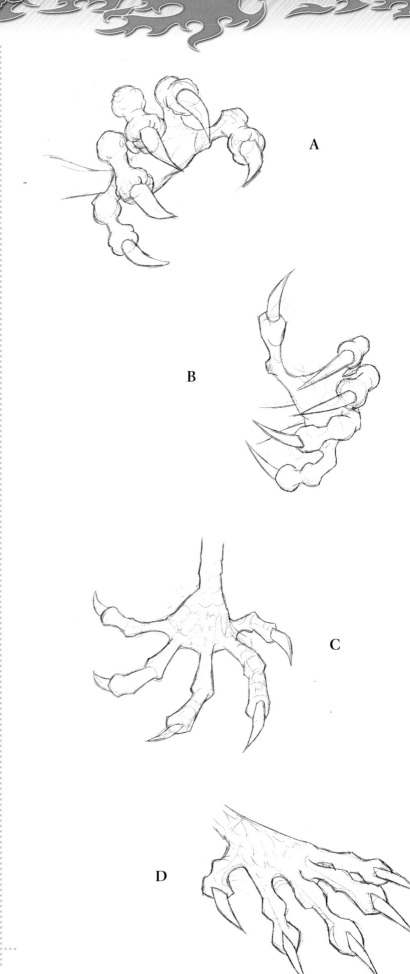

A

B

C

D

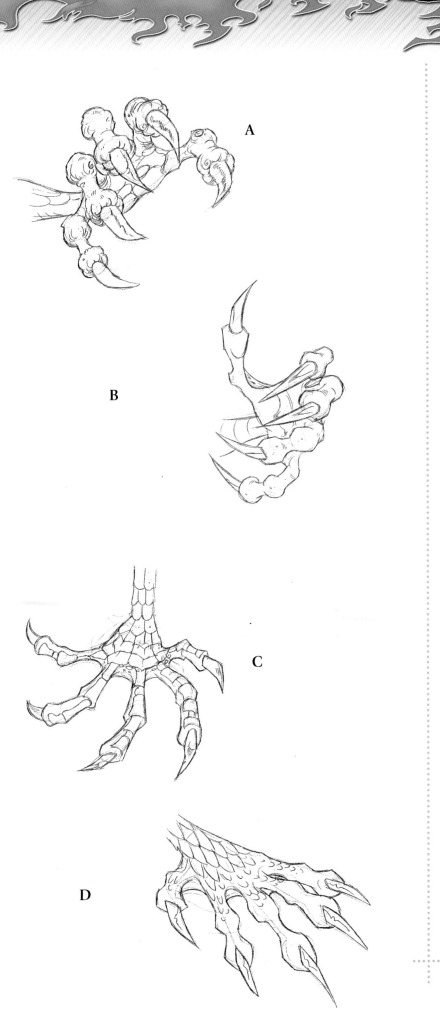

A

Claws: Hands

STAGE 4

A
Add shading to give the hand greater definition and texture.

B, C and D
These hands all have slight 'webbing' between their fingers and thumbs. No one is quite sure why as dragons aren't that keen on swimming. **C** has overlapping scales that run down the arm, over the backs of the hand and along the tops of the fingers. **D**'s scales are more snake-like, giving a lot of flexibility to the wrist.

B

C

D

Claws: Hands

STAGE 5

A, B, C and D

Ink in the overall outline first with a fairly bold line, then use your French curves to get smooth, curved lines for the razor-sharp claws. Finally, carefully add all the details with a fine line. When the ink is thoroughly dry, erase the pencils and 'white out' any mistakes with your pot of bleed-proof white paint.

STAGE 6 *(opposite)*

A

The strong, gripping hand of this Western dragon is a rich green, with pear-coloured claws.

B

This dragon's leathery hand is a yellow ochre colour and features gunmetal-coloured claws.

C

This is the hand of a Mongolian dragon – mustard-coloured, with long, splayed-out fingers.

D

Dragons that live in and near water develop hands such as these. In this particular species, they're a pearly grey with yellowing claws.

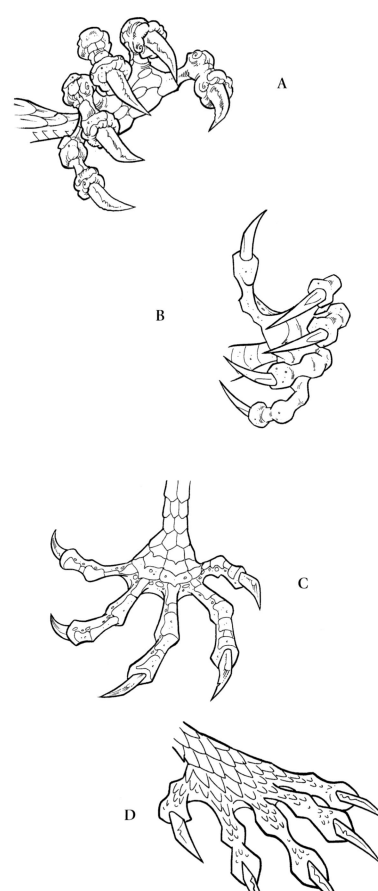

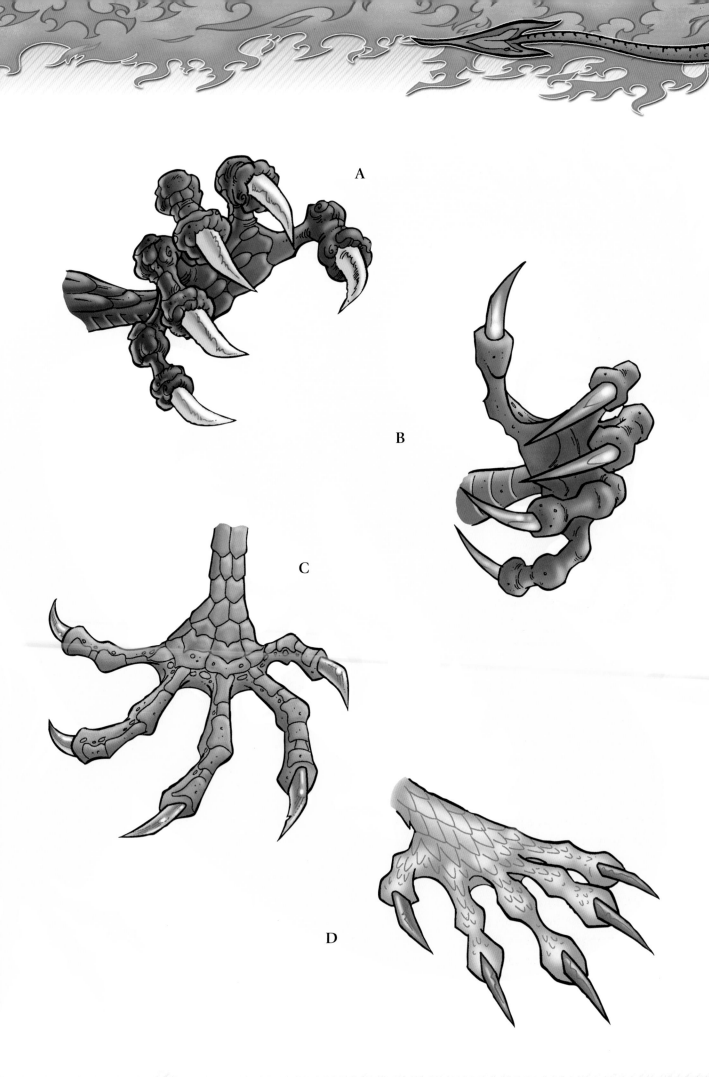

A

B

C

D

Claws: Feet

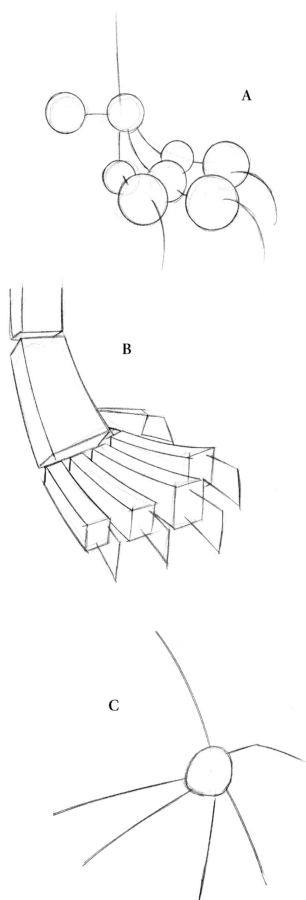

Claws: Feet

STAGE 1

A

Draw circles for the joints (larger ones for the toe tips, smaller ones for the knuckles), three single, curved lines to connect them, and a single, curved line for each claw.

B

Use blocks to build the basic shape, giving the foot a sturdy feel.

C

This foot is very simple. It consists of an oval for the base of the foot with four long, single lines for the toes and another line at the back for the dewclaw.

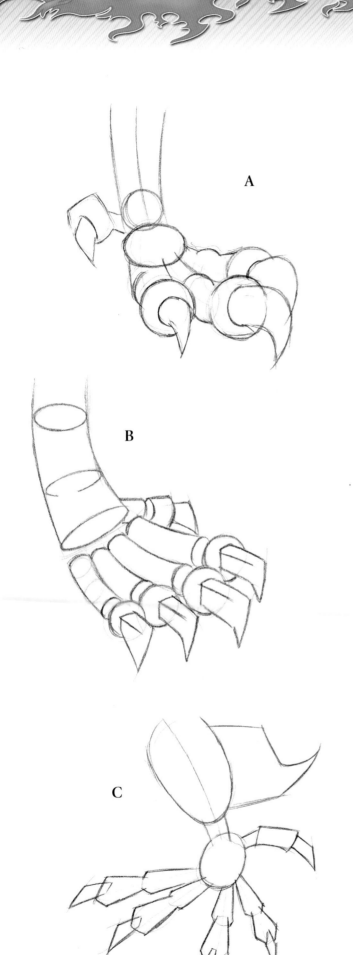

A

B

C

Claws: Feet

STAGE 2

A

Now add an oval between the ankle circle and the toe knuckle circles to give the foot more shape. Flesh out the toes and dewclaw, then pencil in the powerful claws.

B

Draw curved cylinders for the ankle and toes, with circles for the claw joints, drawing angular lines for the claws themselves.

C

This example obviously belongs to an Eastern dragon, with its long, splayed toes. Draw a large oval for the leg, joined to the base of the foot by a couple of vertical parallel lines. Angular lines split into two sections make up the toes, with wedge-shaped claws at the tips and just a rough shape sketched in for the leg hair for now.

Claws: Feet

STAGE 3

A

Add some knobbly bits where the claws join the ends of the toes.

B

Do the same to this example, giving the foot of this beast slight ridges along the tops of its toes, and smoothing out the angular claws.

C

As with the previous two examples, build up the outline of the foot and leg. Round off the sharp, angular lines and give a smoother-flowing definition to the leg hair.

Now build up the basic outline then all that's left to do is to add all the small details, like the shading on the claws and the scales over the toes and legs.

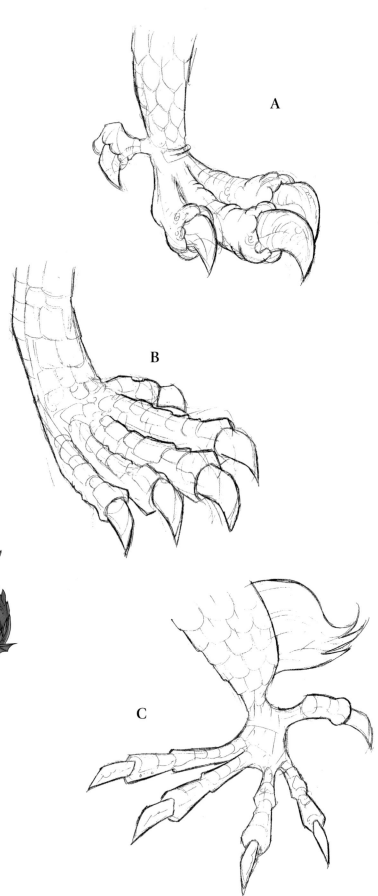

A

B

C

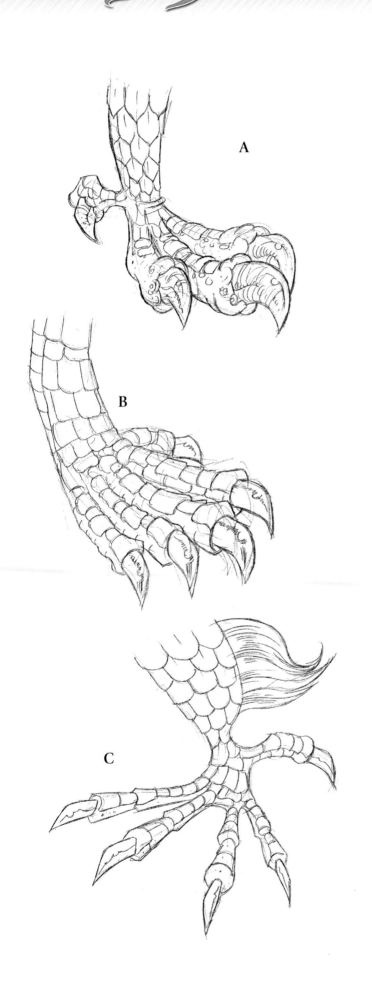

A

B

C

Claws: Feet

STAGE 4

A and B

A is covered in triangular-shaped scales, in contrast to **B**'s more-or-less square ones. The scales increase in size as they progress up the foot and leg, and get smaller heading down over the tops of the toes. Don't forget to add shadow lines to the claws.

C

The toes of the Eastern dragon, in example **C**, closely resemble those of a chicken. Round-edged scales run down the leg to disperse over the individual toes. Add fine lines to give the effect of a glossy sheen on the leg hair.

Claws: Feet

STAGE 5

A, B and C

As with the previous inking examples, start with the bold outline to each illustration. Then, with your finest nib or felt-tip, ink in the scales and claw details carefully. Notice how the shape and thickness of the claws changes as we view them from different angles, most notably in example C.

STAGE 6 *(opposite)*

A

The colouring of this foot is bright, as befits the young, immature male Western dragon it belongs to. The leaf-shaped scales are turquoise and its claws are charcoal-grey.

B

The foot of this wyvern is a bright, glowing yellow – the early morning African sun must be shining on his scales. Its huge claws have a steely, metallic colouring.

C

This is the foot of the rare Chinese dragon, featuring a distinctive, blue colouring fading into beige over the toes. The sharp claws are a light grey.

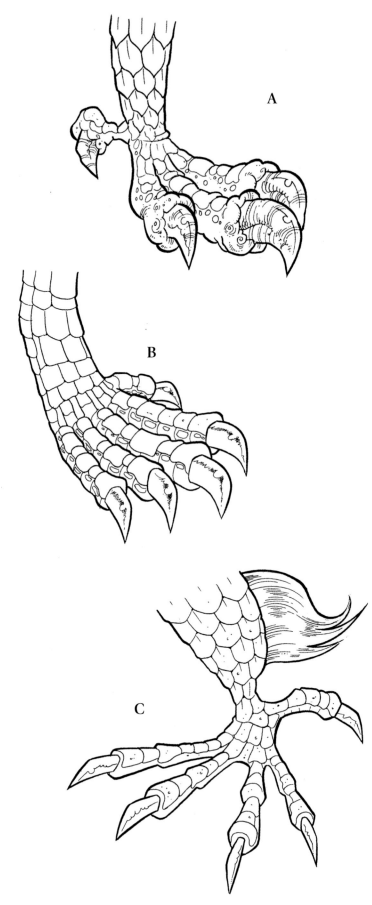

A

B

C

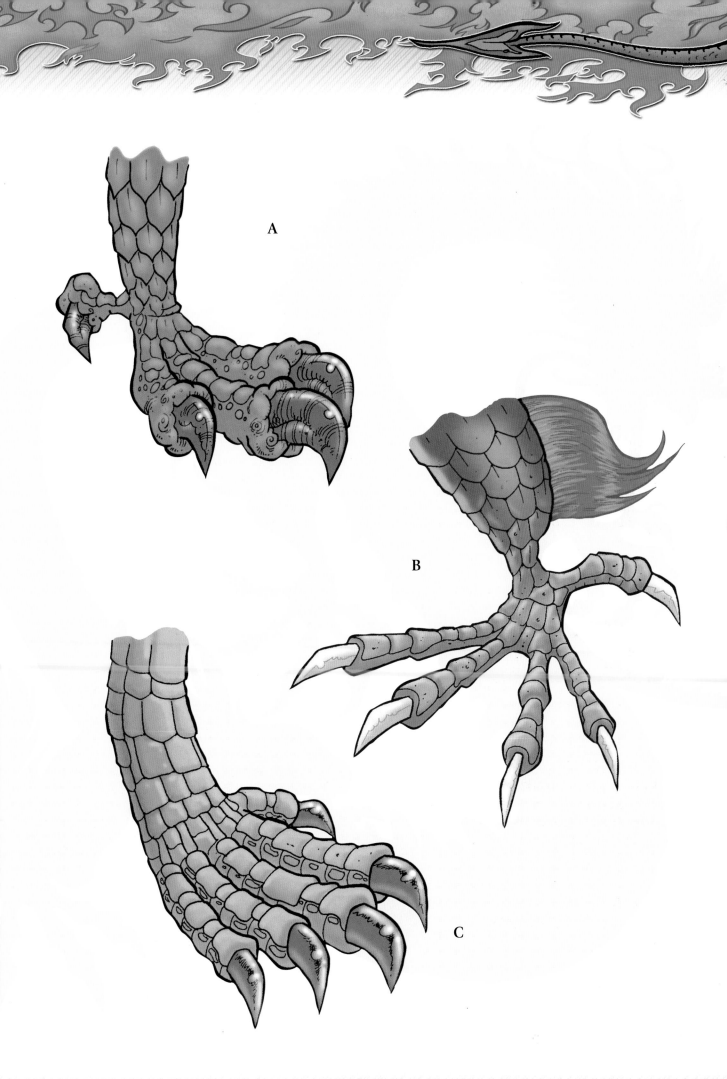

A

B

C

Wings

STAGE 1

A, B, C and D

In each instance, roughly sketch in your basic wing shape, adding dots or circles where the joints will be.

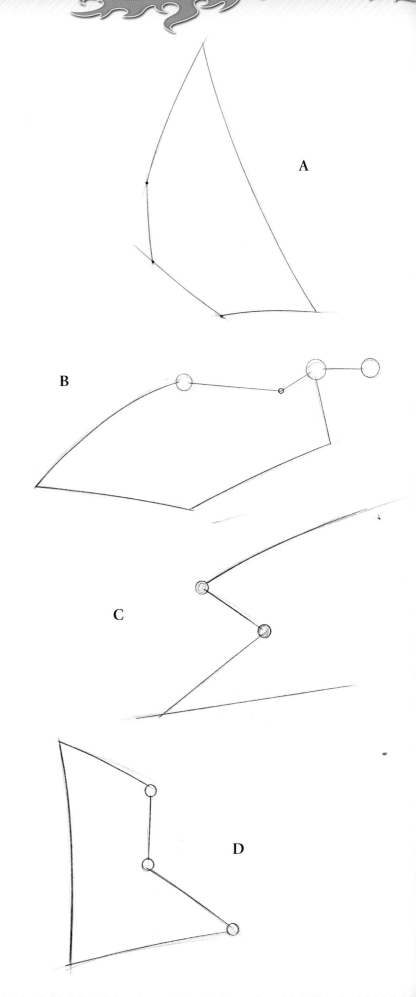

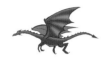

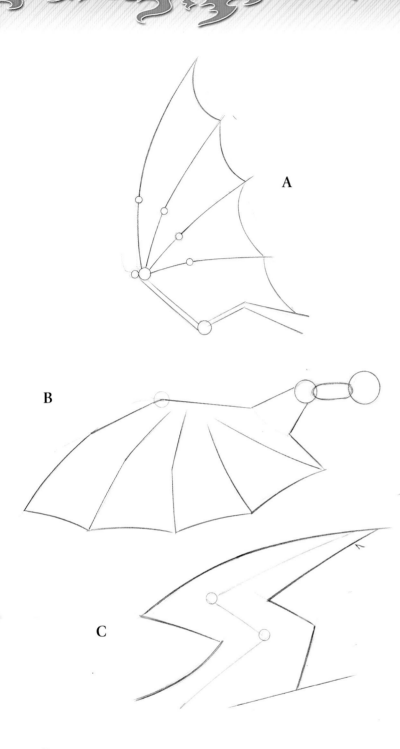

A

B

C

D

Wings

STAGE 2

A

Examples **A** and **D** show the underside of the wings, where the fingers that spread out the leathery skin of the wing are visible. Draw in long, curved lines where the fingers will be, and circles for the joints.

B

Here, we're are looking down on the wing instead, so the bony fingers are not visible. Just draw single lines to indicate where they are.

C

This is the feathered wing found on Central and South American dragons. Build up the wing shape around the first simple 'zig-zag' line.

D

This is almost bat-shaped, and only has three fingers instead of the four that example **A** features.

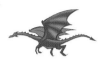

Wings

STAGE 3

A

Add a line from the top of the first joint to the shoulder.

B and C

Shape the shoulder muscles of **B** and emphasize the arm and fingers beneath the wing membrane more. Sketch in the basic guidelines for the underside of the feathered wing in example **C**.

D

Build up the arm and shoulder and add more shape to the bottom of the wing.

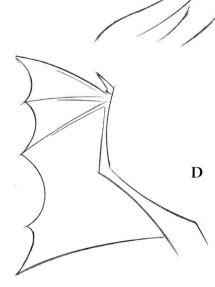

*Now start to build up all the wing shapes. Curve all your lines and individualize the exposed fingers in **A** and **D**, then finish the main structure of all the wings.*

A

B

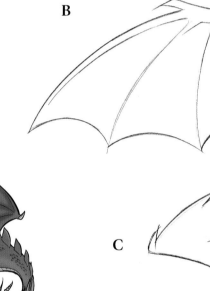

C

D

Wings

Stage 4

A

Add little lines to indicate the stretched membrane between the fingers.

B

Add little hooks to the ends of the wing, and a curve to the main one on the top of the wing.

C

Draw in all the feathers, adding some longer ones at the shoulder.

D

Put a few rips in the lower wing to give it a weather-beaten look. Also add a stretch of skin from the claw to the shoulder.

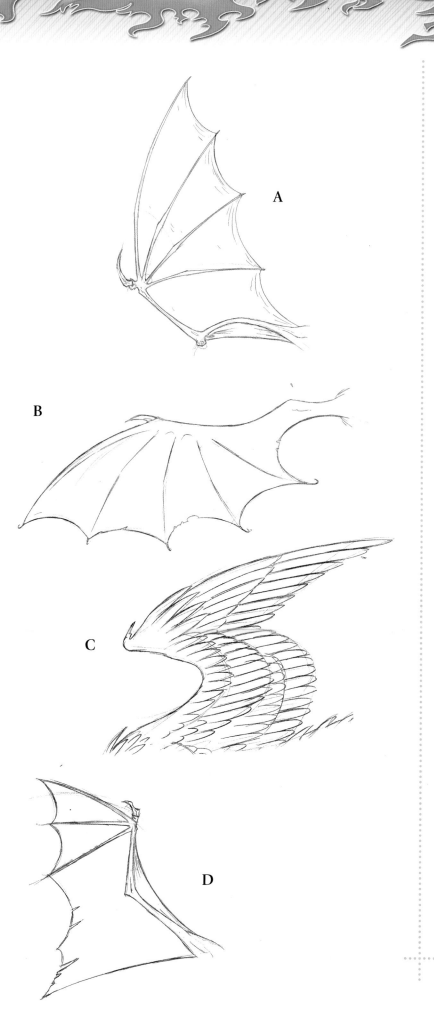

Wings

STAGE 5

A

Add a veiny pattern to the wing membrane.

B

Sketch in finer detail on the shoulder muscles and add a few tears and holes to the wing.

C

Draw centre lines down the individual feathers and add a few fine lines to some of them to break up their smooth lines.

D

Add little lines to show the stretched membrane between the fingers, and where the wing is attached to the body.

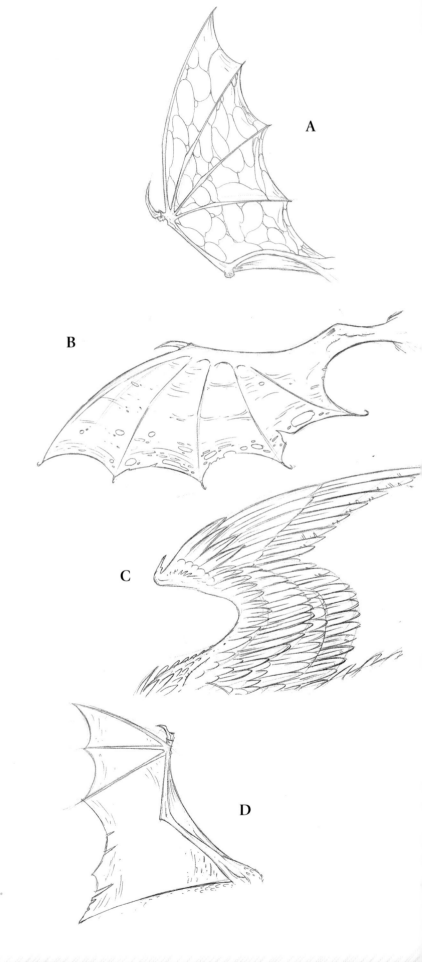

Wings

STAGE 6

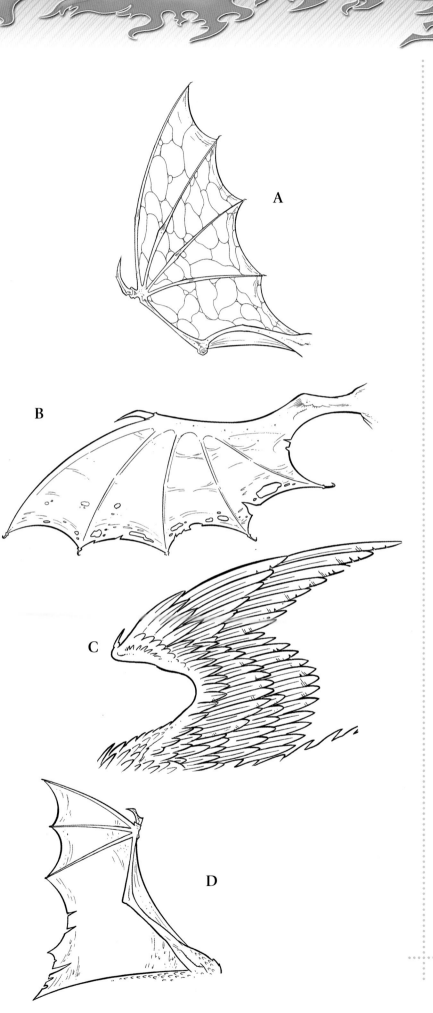

A

B

C

D

As you know by now, when inking, use a thickish line for the outer pencils and a thin line for the details within. For long, curved lines such as these wings, French curves are the perfect solution.

Wings

STAGE 7

A

This, of course, is the mottled wing of an African dragon. A yellow, leathery membrane is stretched between the brown wing fingers.

B

This wing belongs to the evil dragon of northern Europe. A particularly bad-tempered creature, with purple skin and mottled blue wings.

C

The dark purple-blue feathers of this male South American dragon are unmistakable.

D

This wing, with a highly textured indigo wing membrane, belongs to a very pretty little southern European dragon.

These are some other dragons' wings to try your hand at drawing…

Meet the Dragons

There are a myriad of different dragons to be found around the world, but for the purposes of this book we'll just be concentrating on the following main ones:

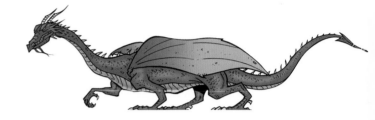

◁ Western Dragon

The Western dragon is the embodiment of wickedness, a cold-hearted reptile that uses its fiery breath to leave burning destruction in its wake. It has a pathological desire to hoard vast quantities of stolen gold and jewels which, with scheming eyes, two rows of sharp teeth, taloned hands and tearing claws, it jealously guards. Its head and back are festooned with horns and spikes and covered with armoured scales, making the Western dragon all but indestructible. However, a few warriors have discovered its one weak spot, managing to kill a number of them by dispatching them with a lance down the throat.

Eastern Dragon (Tibetan) ▷

A great lover of high altitudes, the Tibetan Eastern dragon is thinner than its Asian cousin, which you'll meet next. For the most part, the Tibetan dragon is seen as a benevolent helper of humans. This divine dragon can bring down rain to help fertilize land though, if caught and held captive, extensive periods of drought may result.

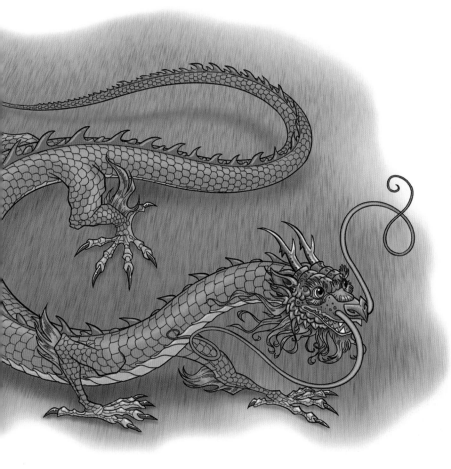

◀ Eastern Dragon (Asian)

The Asian Eastern Dragon is regarded with great affection. It is most frequently found in close proximity to the stream, river or lake where its underwater lair is hidden. The female carries her eggs with her for safety,and these are sometimes mistaken for pearls. It is said this dragon watches over water carriers and boatmen. In Asian mythology, there are 360 'scaly' creatures, and the dragon is so revered it appears at the top of the list.The Asian Eastern dragon is thought to be a descendant of *Nagas*, the infamous Indian dragon.

Eastern Dragon (Mongolian) ▶

The Mongolian dragon physically resembles the Tibetan and Asian dragons, though it's much longer and more serpent-like. Its temperament, however, is more akin to the mean nature of the Western dragon. It inhabits a harsh environment and, sadly, has a nature to match.

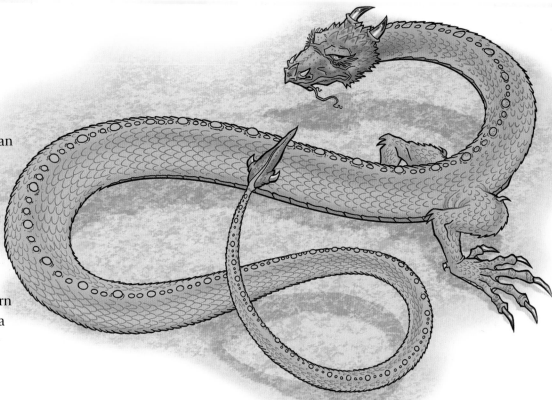

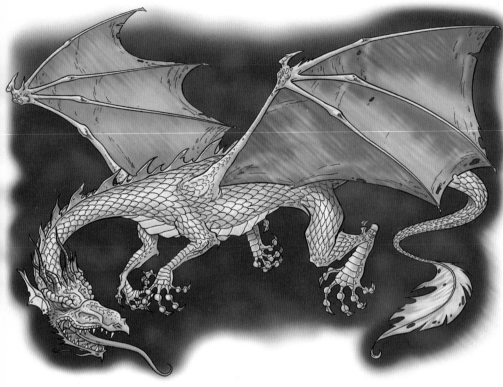

◂ North American Dragon

Native tribes living in close proximity to the North American dragon say this creature is famed for knowing all the secrets of the world. It is perceived as being closely associated with nature and the forces that drive the natural order of the earth. Unfortunately, this dragon is now rarely seen, since humankind's continual abuse and plundering of nature has caused the world to all but lose its natural balance.

Central and South American Dragon ▸

It's believed that this plumed, serpentine dragon, like the Asian Eastern dragon, has close links with water, which will come as no surprise to all you dragonologists out there. However, unlike the previous dragons mentioned, which seem to fall into two separate camps – good or evil – the Central and South American dragon possesses both traits. It does not represent divine power like some dragons in the East, nor does it possess the terrible evil that the Western dragon does and, as a result, it has an enhanced sense of earthly harmony.

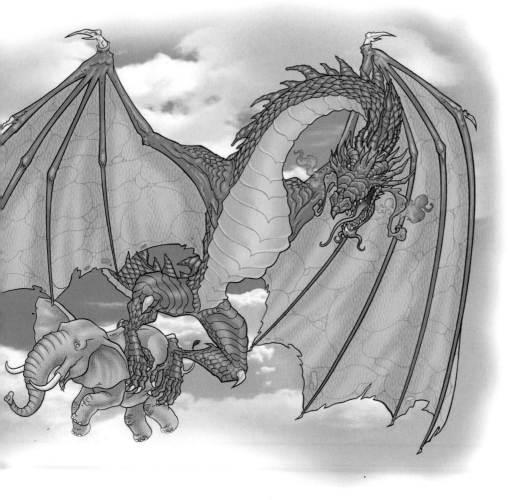

◄ African Dragon

The African dragon, or wyvern, is closely related to the Western dragon, and resembles it in every physical way except for the fact that it doesn't have forelimbs. Rather than develop separate wings, it's the wyvern's arms themselves that have evolved to empower this huge dragon with the ability to fly. Its temperament is akin to its aforementioned cousin, and the saying 'never look into the eyes of a dragon' is especially true with this species, as it possesses highly hypnotic powers. The acid-yellow blood is extremely toxic and can actually kill if splashed on exposed skin.

Knucker Dragon ►

And, finally, a quick word about the Knucker dragon. This is a rather small dragon, which doesn't actually feature in this book, but which deserves a brief mention. It's mainly found down dark, dank holes deep underground, or occasionally at the bottom of disused wells, where it waits patiently in the hope that some unfortunate victim will accidentally tumble in.

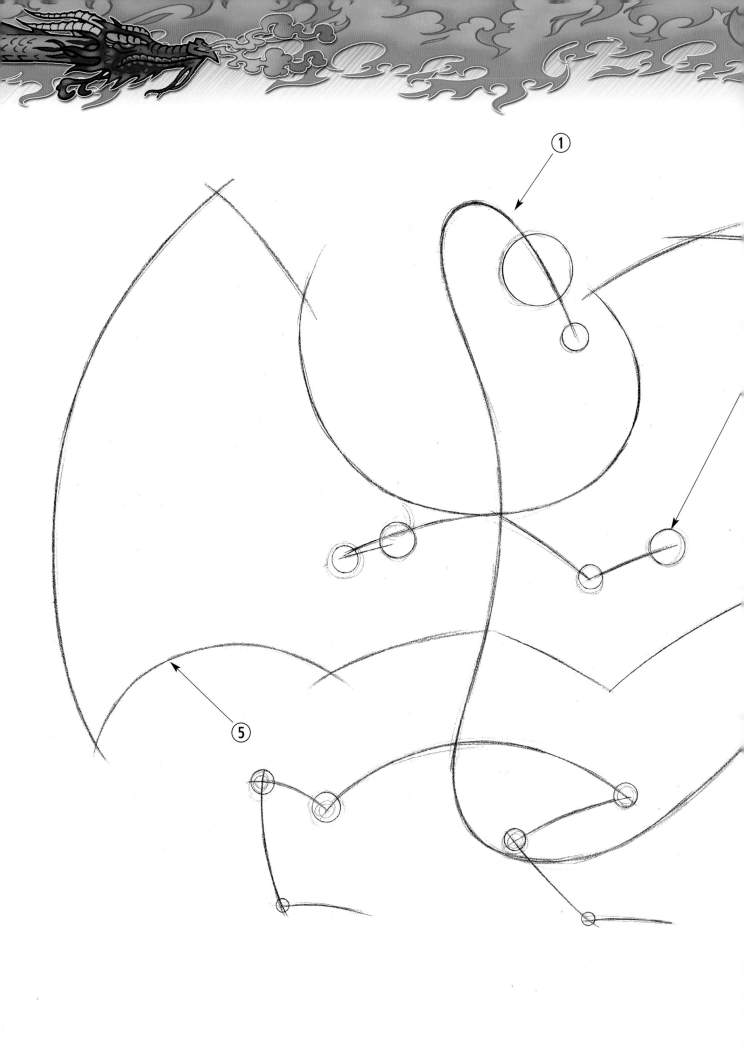

◇Western Dragon◇

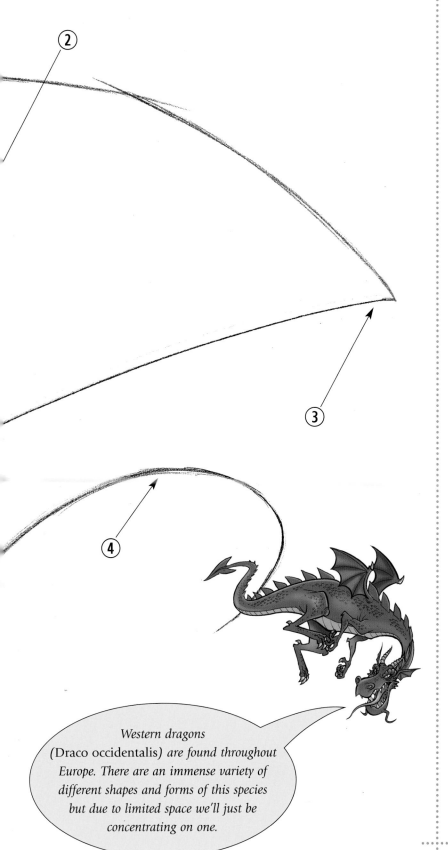

② ③ ④

Western dragons (Draco occidentalis) are found throughout Europe. There are an immense variety of different shapes and forms of this species but due to limited space we'll just be concentrating on one.

Western Dragon

STAGE 1

Step 1:
Start by drawing your 'centre line'. When drawing dragons, this is the curve you want your dragon's body to have. Then, add a circle as a guide to where the dragon's skull will be, plus a smaller one where the lip of his nose will be.

Step 2:
Build a rough stick skeleton for the arms and legs, with circles where the elbow or knee joints are. The arms are fairly human but the legs definitely belong to a lizard.

Step 3:
Roughly plan your wing shape, one slightly folded, the other stretched fully out.

Step 4:
The tip of the tail will feature a sharp, arrow-like point.

Step 5:
Note the points on the wings where this species of dragon has evolved large talons. The wingspan is roughly equal to the measurement from its nose to its tail.

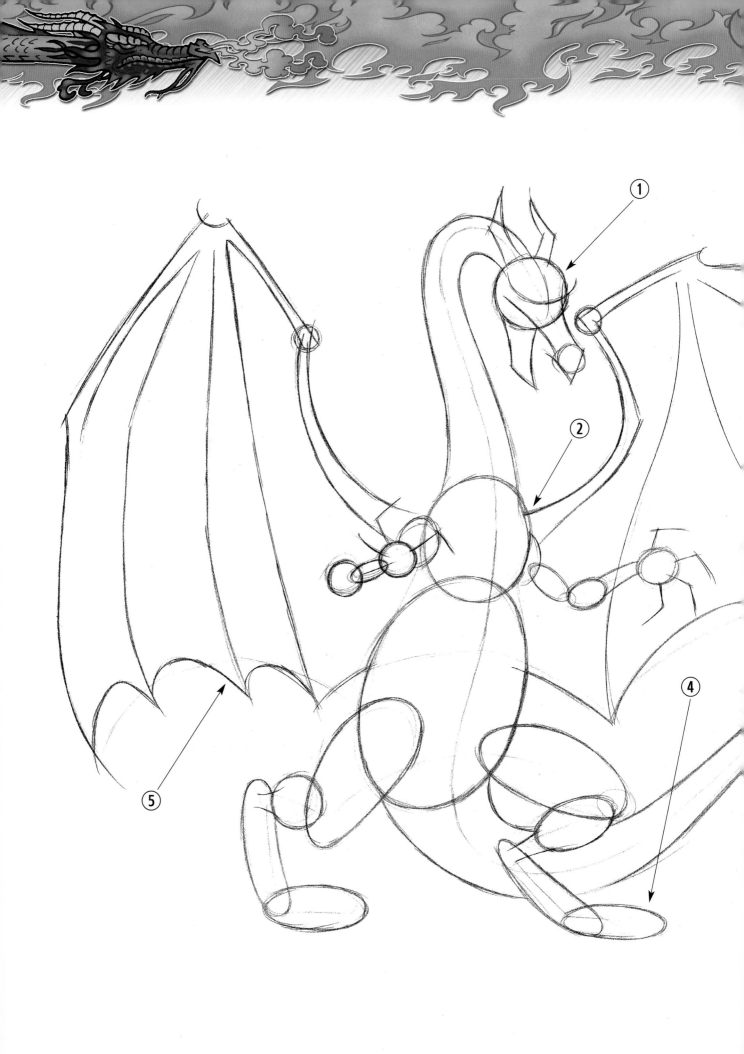

Western Dragon

STAGE 2

Step 1:
Start to build the body, fleshing it out by adding ovals to your stick skeleton, and sketch in the horns and jaws.

Step 2:
Build up the muscular wing supports, which are joined to the dragon's back where the shoulder blades are situated.

Step 3:
Add another oval to indicate the position of the triangular tail-tip.

Step 4:
Add two long ovals for the feet, which need to be strong enough to bear the dragon's incredible weight.

Step 5:
Define the wings a bit more, adding lines where the 'fingers' that support the large, feathered wings will be.

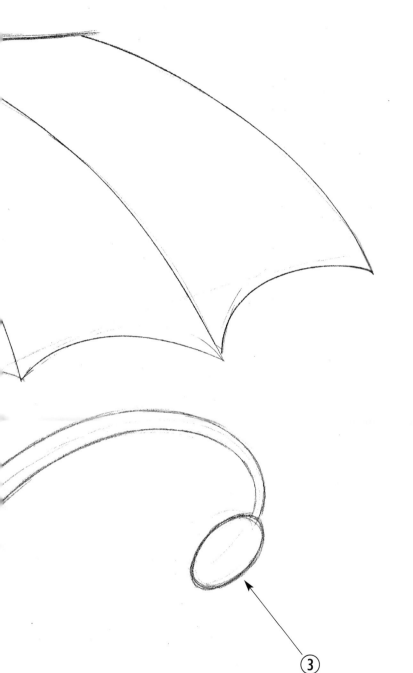

③

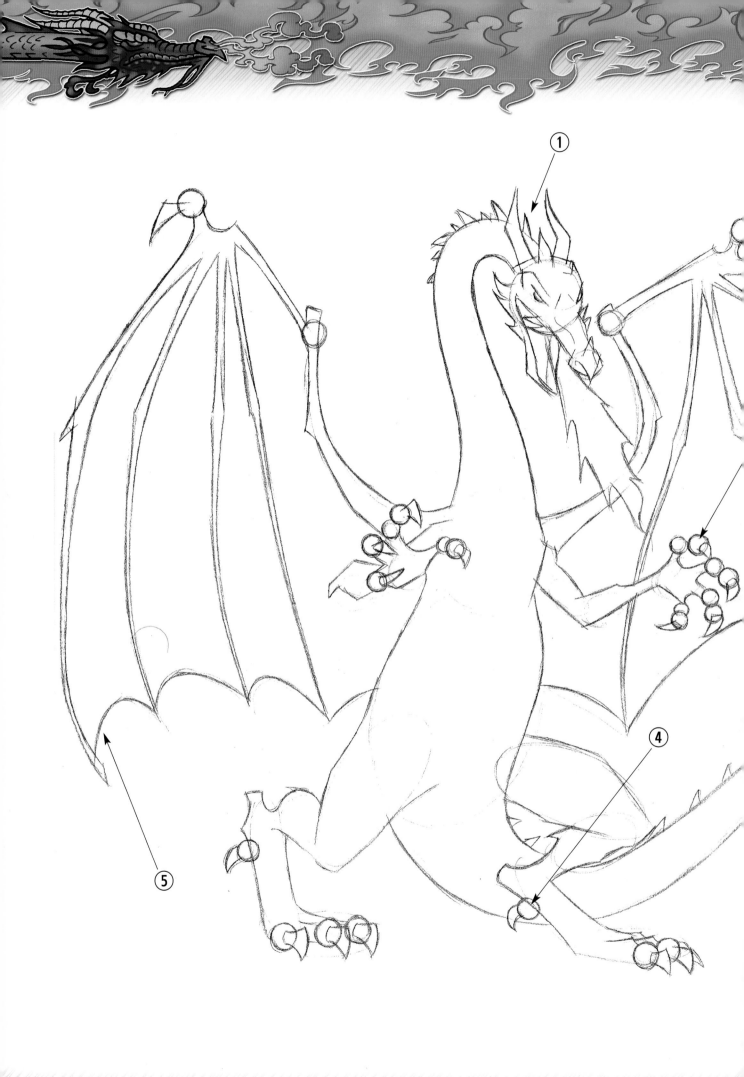

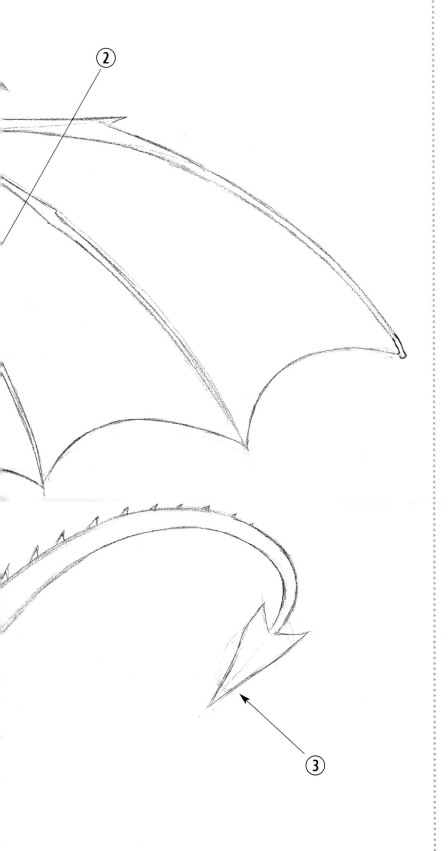

Western Dragon

STAGE 3

Step 1:
Now, carefully start to construct the head and body, adding lines to indicate how you would like the head and body shape to develop.

Step 2:
Draw circles where the knuckles and joints on the hands will be, plus the claws.

Step 3:
Shape the triangle at the end of the tail.

Step 4:
The same goes for the feet. Note the dewclaws at the back of the elongated feet.

Step 5:
Do a bit more work on the wings, developing the fingers and the large claws on the top of the wings.

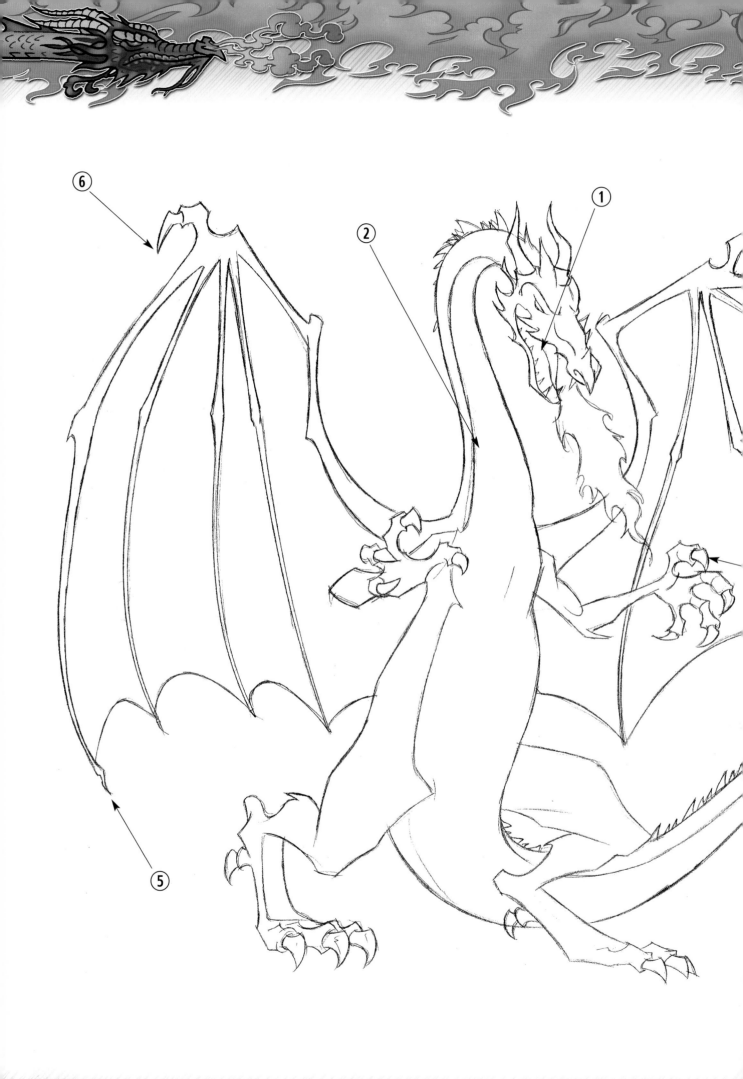

Western Dragon

STAGE 4

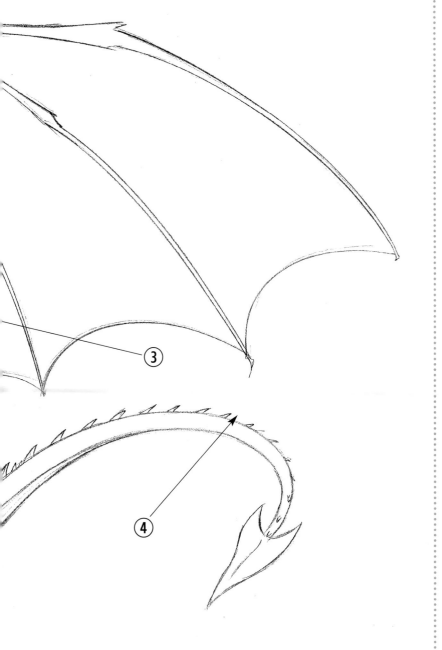

Step 1:
Your dragon should be really shaping up nicely now. Add the teeth, and give more shape to the flame blasting from its mouth.

Step 2:
Lightly sketch in the line where the front body scales will descend from its throat all the way down to the tip of the tail. Note how the tail twists over towards the tip.

Step 3:
Carefully build up the hands, giving greater definition to the fingers and claws, and doing the same for the feet.

Step 4:
Roughly sketch in the jagged spines that run down the back from its head to the tip of the tail.

Step 5:
Add claws to the ends of its wing fingers.

Step 6:
Give more shape to the claws on the top of its wings.

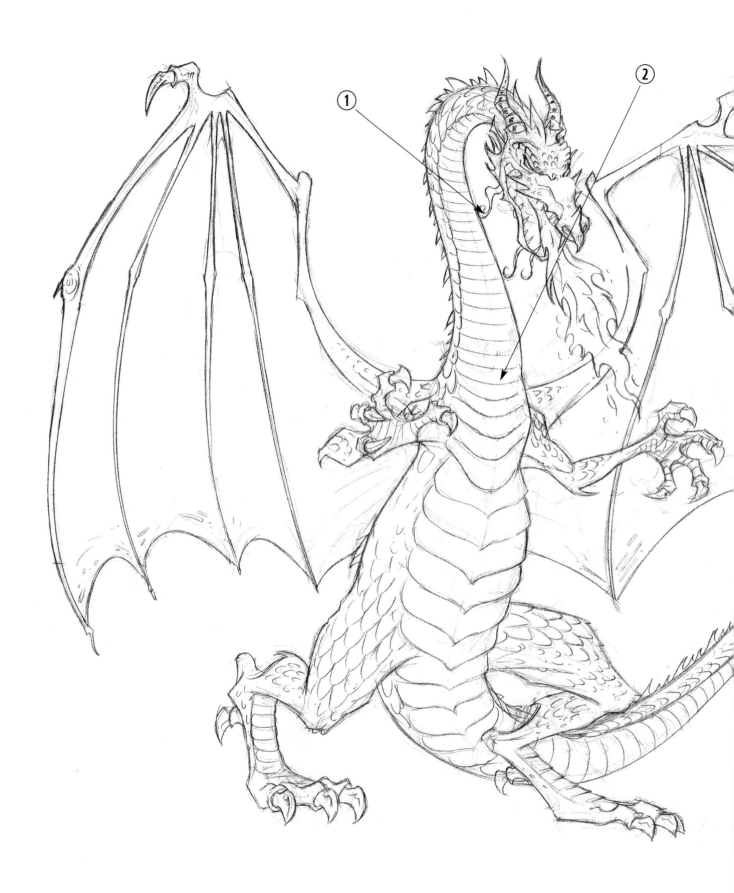

① ②

Western Dragon

STAGE 5

Step 1:
This is the final pencil stage. Draw in the leathery flaps that hang down from the dragon's jaws, add the scales over its eyes and the shine to its horn ridges.

Step 2:
Draw all the 'under' scales down the front of its body and indicate the overlapping scales over the rest of it.

Step 3:
Add a few lines to indicate a worn, leathery feel to its wings.

Step 4:
Shape the arrow-tipped tail and add a couple of sharp spines to the two back points.

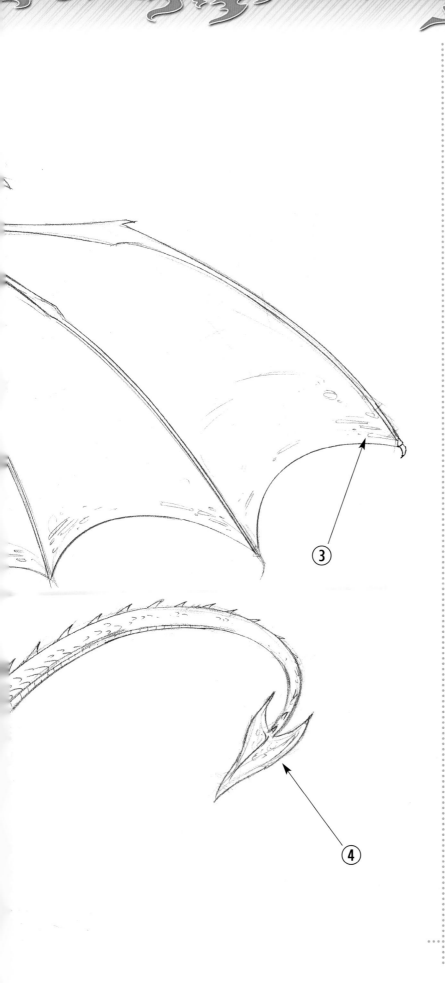

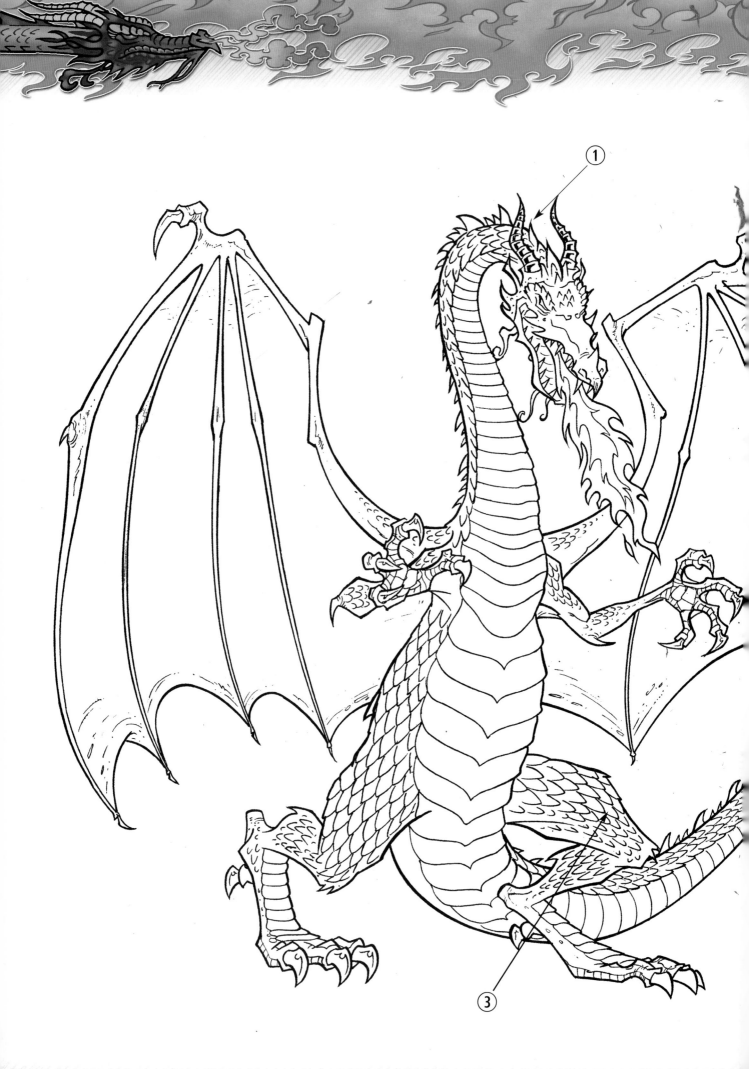

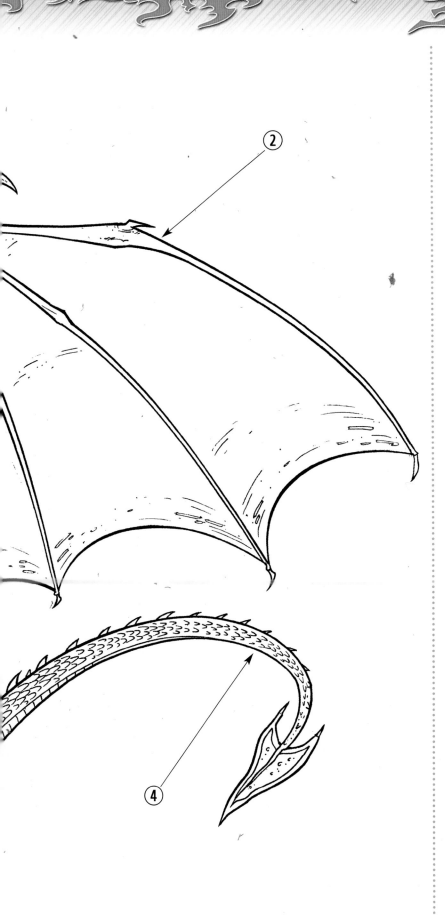

Western Dragon

STAGE 6

Step 1:

Begin by inking in the outline using a fairly bold line. A brush pen is pretty good for this.

Step 2:

To achieve the long, smooth line, which is needed for the wing supports, use your French curves. A felt-tip and dip pen is best for inking these.

Step 3:

Using a much thinner line, ink in the scales on your dragon's body and for all the small details.

Step 4:

Again, the French curves come to the rescue when inking in the curve of the tail.

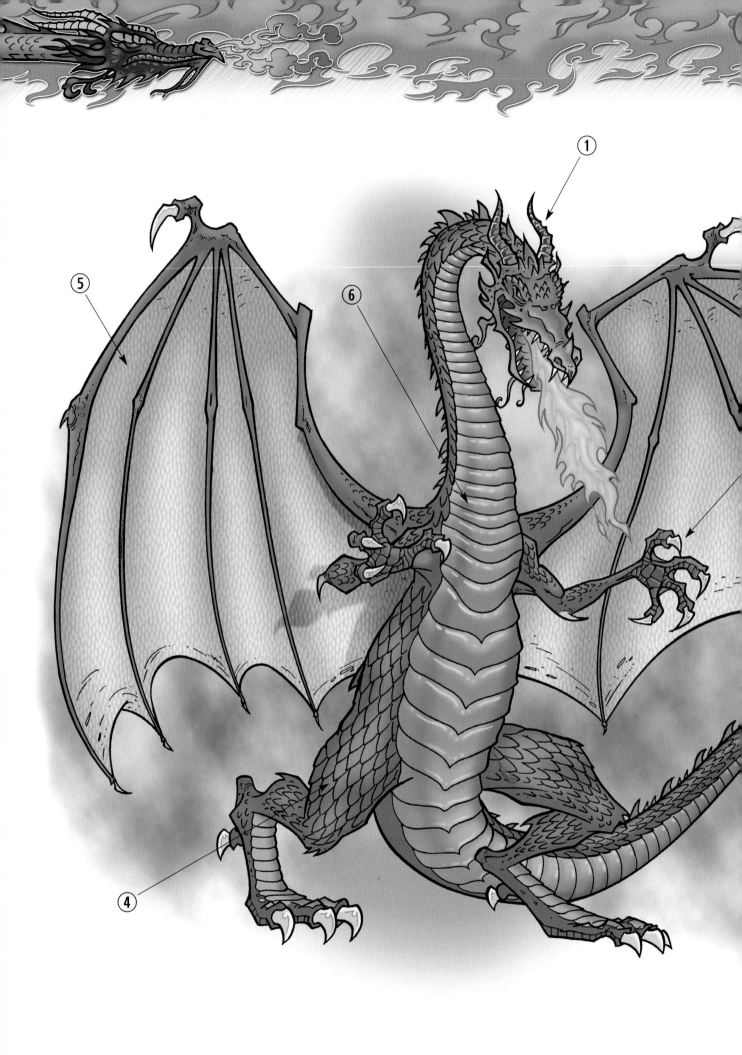

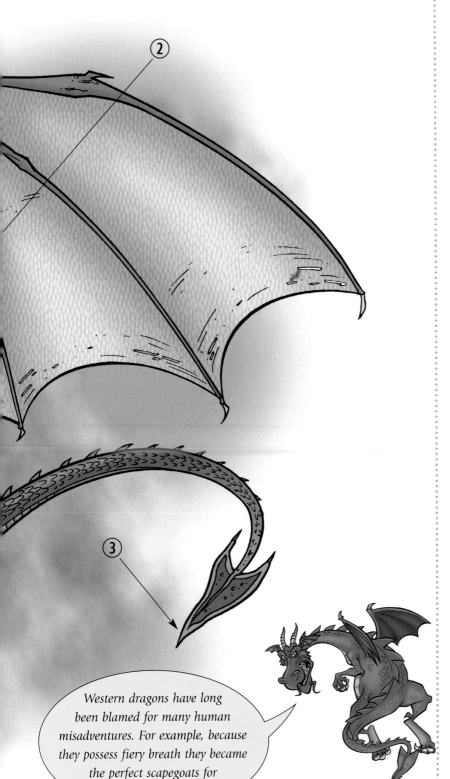

Western Dragon

STAGE 7

Step 1:

The mature Western dragon's horns are a gunmetal-colour (note how these have been shaded to highlight their deep ridges), and its main skin colour is olive green.

Step 2:

The talons are a lighter shade of the colour of the horns, and have a smooth surface, which means there's less shading to do on these.

Step 3:

The arrow-like tip of the tail is two-tone, combining the main colour of the dragon's skin and the lighter shade of its underbelly.

Step 4:

The dragon's rough, scaly skin is a paler shade of green everywhere the light hits it.

Step 5:

The inside of the wings are a speckled lime-green colour.

Step 6:

The dragon's underbelly is shaded in such a way as to make the skin look taut and muscular over the thick ridges.

Western dragons have long been blamed for many human misadventures. For example, because they possess fiery breath they became the perfect scapegoats for unexplained fires.

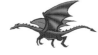

Eastern Dragon (Tibetan)

STAGE 1

Step 1:
For the Tibetan Eastern dragon, we start with a circle for the skull, an oval for the nose, a triangle for the snout and rough square for the headplate.

Step 2:
Pay particular attention to the centre line as it sweeps around and back on itself.

Step 3:
Use the old, tried-and-tested circles and sticks to position the shoulders, elbows and hands of the forearms.

Step 4:
Do exactly the same for the hind legs. You'll have to judge the right positions for these limbs by eye. Remember, the legs have more joints than the arms: hip, knee, heel and forefoot.

Step 5:
Mark in the fingers with a few deft strokes of your pencil. These are slightly curved, while the toes are splayed but straight.

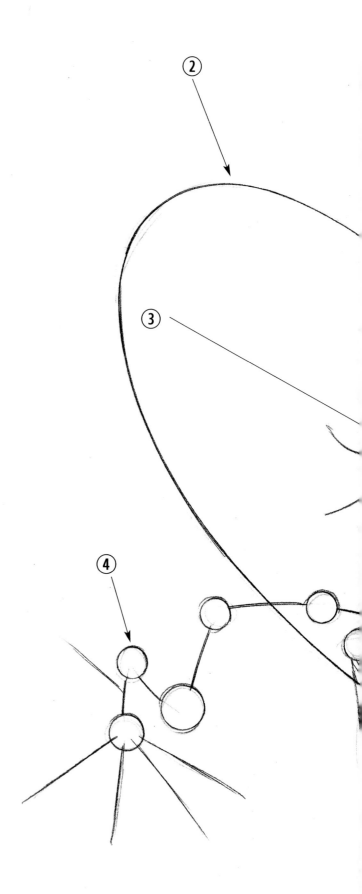

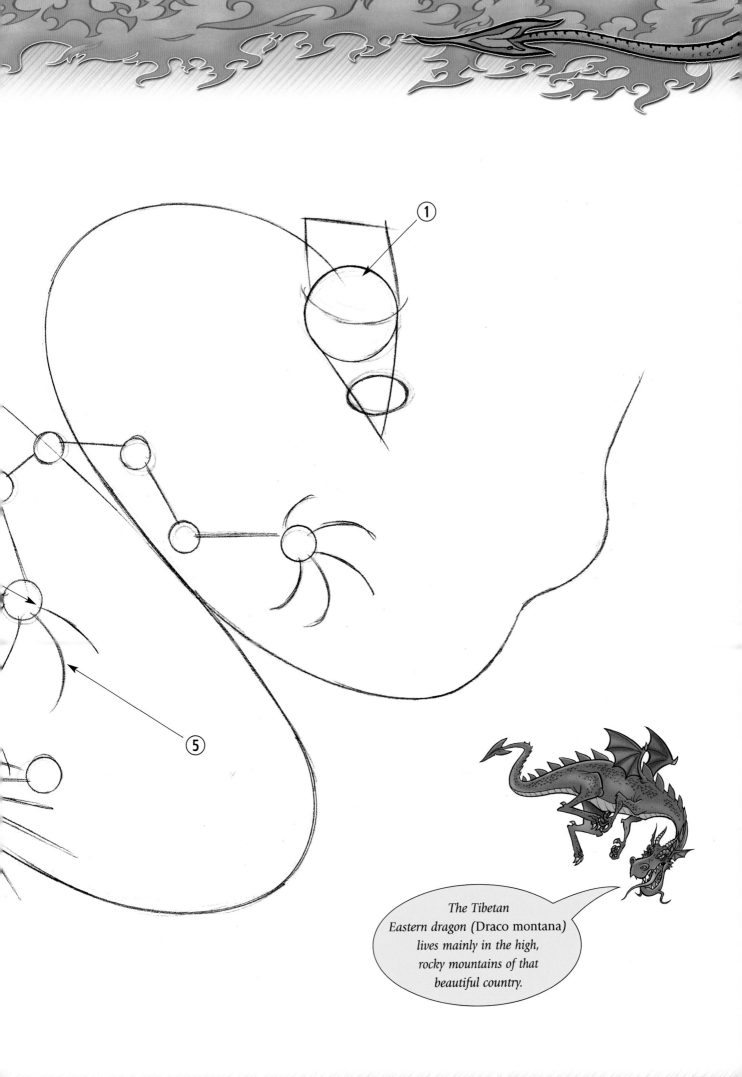

The Tibetan Eastern dragon (Draco montana) lives mainly in the high, rocky mountains of that beautiful country.

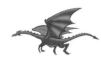

Eastern Dragon (Tibetan)

STAGE 2

Step 1:
Place two eyes in the circle for the head, add a triangular lower jaw, pixie ears and flowing lines indicating the whiskers and four horns.

Step 2:
Form the snake-like body with a series of ovals and circles. Draw the body shape by joining together the outer edges of the ovals and circles.

Step 3:
Start to build up the forearms and hands using circles or tubes. Use curved lines for fingers and smaller circles where the knuckles will be. Also, roughly sketch in the elbow hair.

Step 4:
Build up the legs with fairly large ovals and circles. As with the hands, the feet consist of four lines with two circles on each to position the knuckles – and don't forget the dewclaw at the back or to indicate where the tufts of leg hair will be.

Step 5:
Tibetan dragons have rather long, flowing hair at the end of their tails. Use two overlapping shapes to indicate the rough design of this.

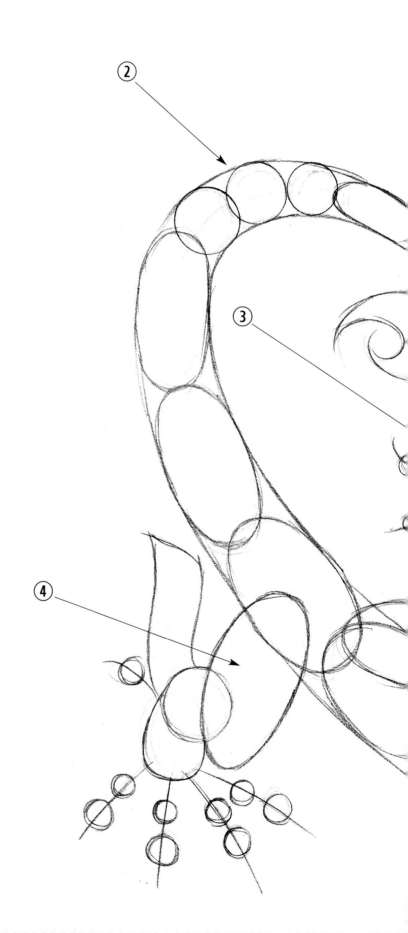

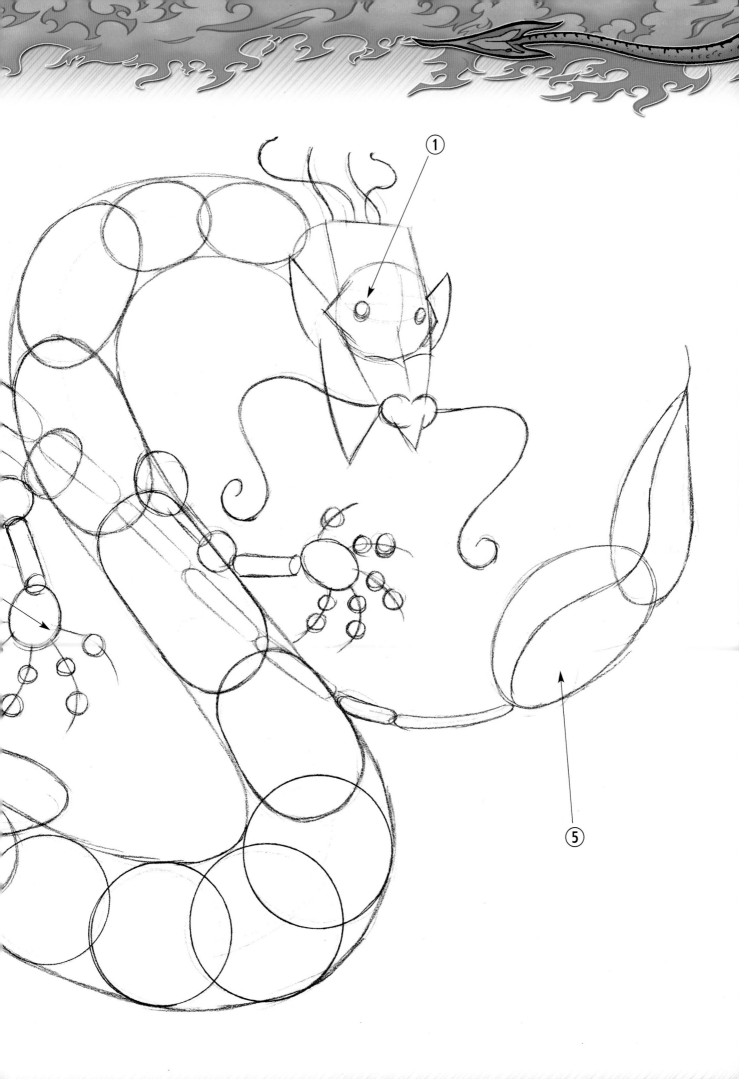

Eastern Dragon (Tibetan)

STAGE 3

Step 1:
Draw the headplates on top of the head. Then add the lines that will define the dragon's facial features, including the swirls for its unusual nose. Fill out the horns, whiskers and spiky bits around the ears and lower jaw.

Step 2:
Sketch in the backbone line, placing bumps along it which will be his spines.

Step 3:
Start to shape the arms. He has short upper arms, merging into the shoulder, with a disproportionately longer forearms. Build up the fingers and claws too. Develop the arm hair into a more flowing shape.

Step 4:
Use an angular pencil line to define the muscle shape of the legs and develop the leg hair, toes and claws.

Step 5:
Lightly sketch in the guideline for the decorative breastplate.

Step 6:
Develop the feathery tail hair. Try to achieve a twisting, flowing design.

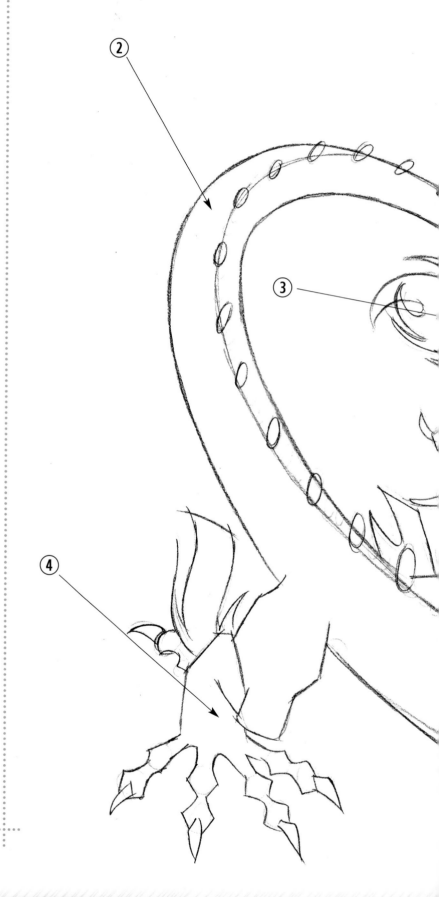

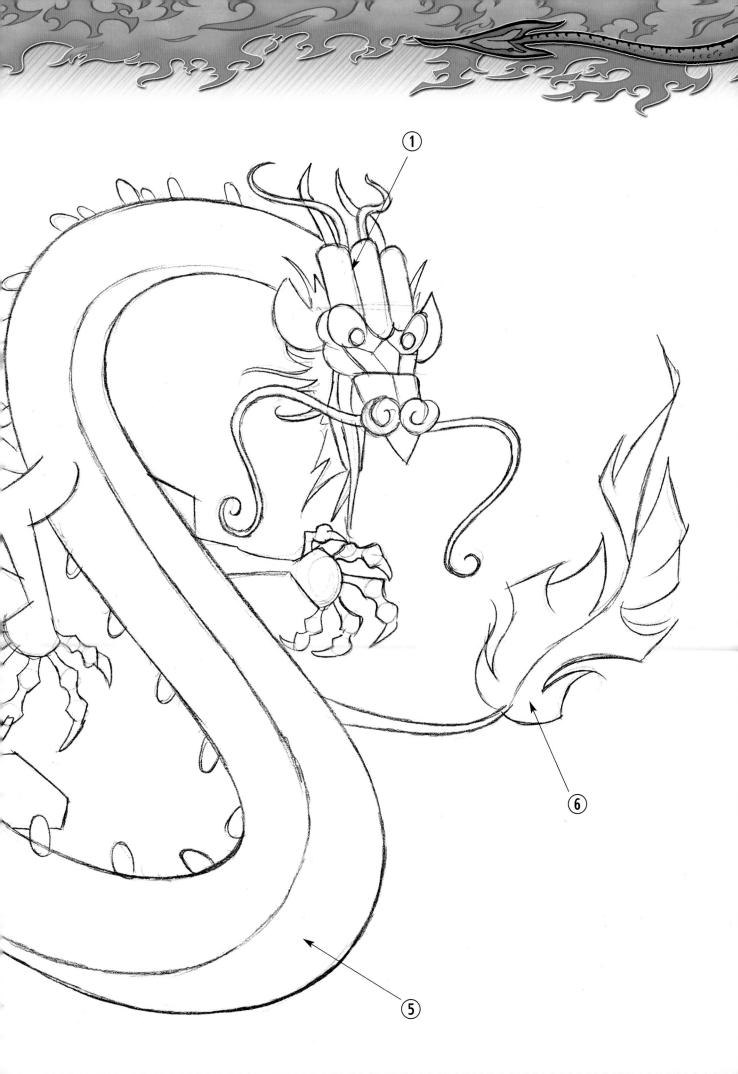

Eastern Dragon (Tibetan)

STAGE 4

Step 1:
Very carefully, build up the facial details such as the eyes, the feathery eyelashes, the hairy ears and nose and the detail under the jaw. Don't forget to put in the teeth and tongue, too.

Step 2:
Add more back spines: one large set with smaller ones placed just in front.

Step 3:
Go over the arms and hands, shaping in the muscles and finger joints more clearly. Build up the hair flowing from the arms, too.

Step 4:
As you build up the legs to the desired shape, indicate the folds of skin at the ankle with a few lines. Add wrinkles over the toe joints, too.

Step 5:
Start to build up the design for the ornate breastplate.

Step 6:
A few more lines added to the tail makes it begin to look very luxuriously feathery indeed.

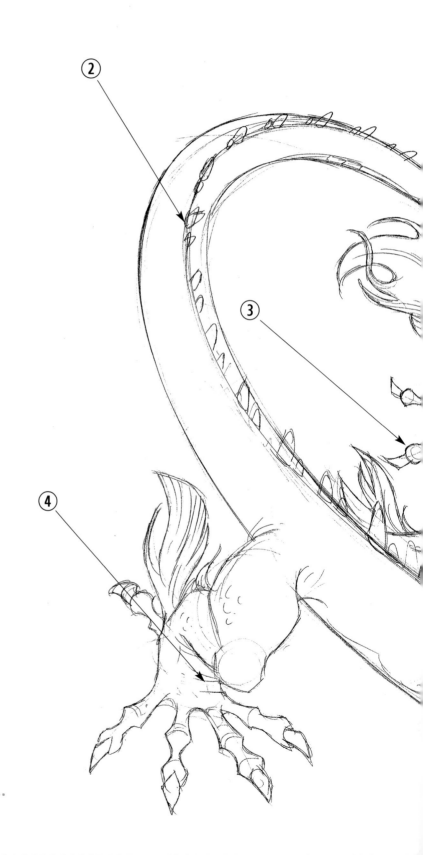

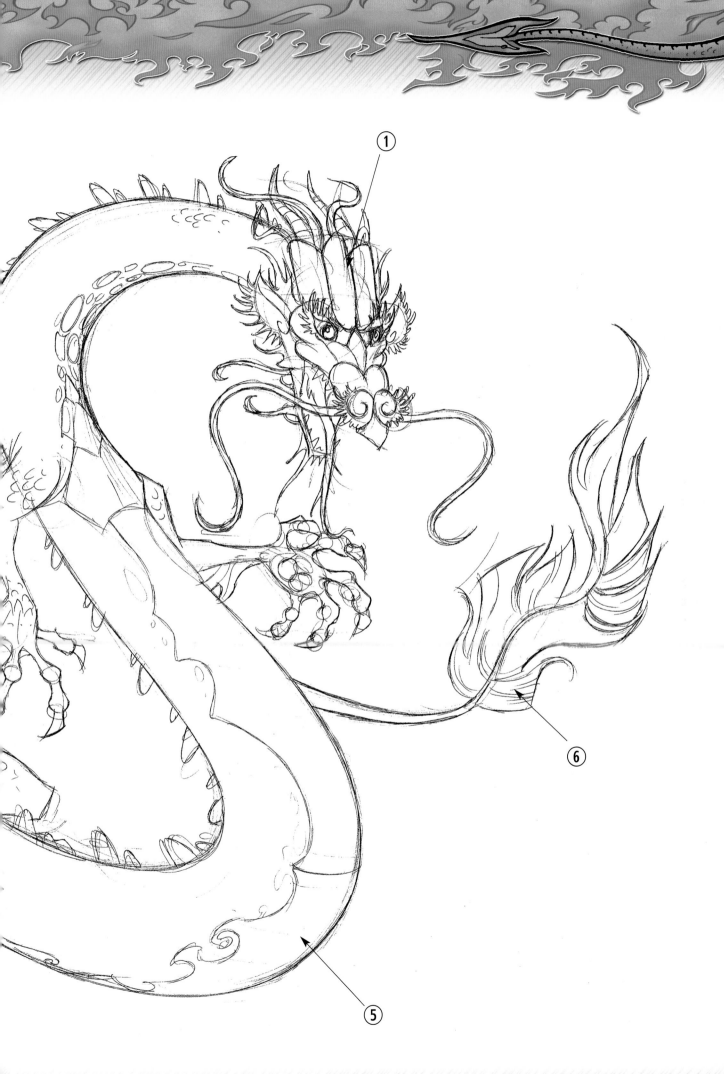

Eastern Dragon (Tibetan)

STAGE 5

Step 1:
For the final touches on the head, add the swirls in his ears, the pattern on the three headplates and define the ridges on the horns. Pencil in the shading in the eyes and the pupils.

Step 2:
Indicate the flow of scales covering the upper body, noting how they become smaller as they travel down from the shoulder to the fingers.

Step 3:
Add more lines to the arm hair and webbing between the fingers.

Step 4:
Make the same improvements to the legs as you did to the arms. Notice how the claws change shape when viewed from different angles.

Step 5:
The breastplate is complete and, although still fairly strong, is far more pliable than the breastplates of other dragons.

Step 6:
More lines should now be added to the tail feathering, plus a few plates on the palm of the exposed left hand.

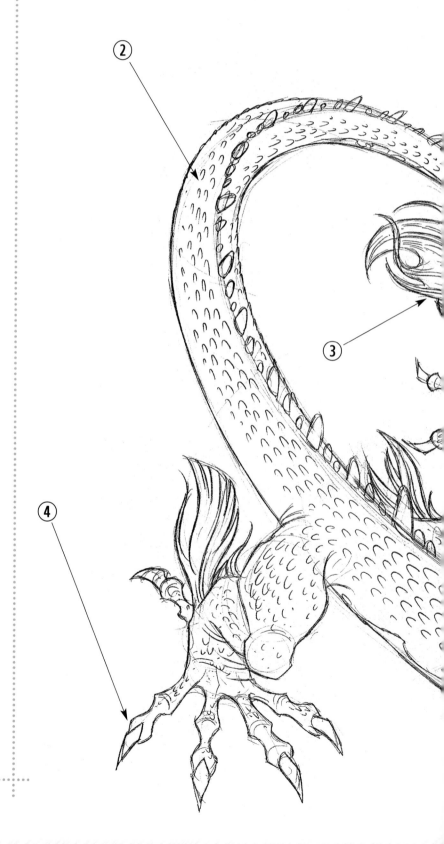

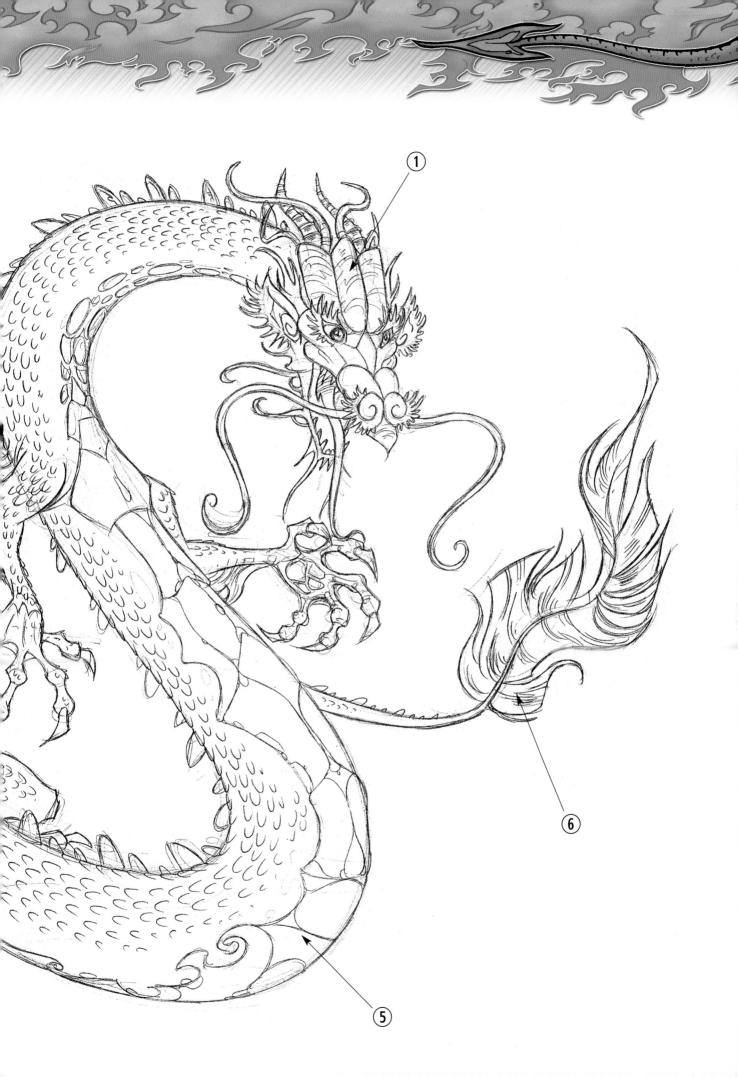

Eastern Dragon (Tibetan)

STAGE 6

Step 1:
Carefully ink in the head as there's a fair amount of detail there. Use a thick line for the outside lines and a fine line for the details such as the teeth, eyes and headplate patterns.

Step 2:
You don't have to follow every pencil line religiously; small adjustments can be made even at this stage. Don't forget to use your French curves when you want a smooth, curved line.

Step 3:
Ink in the highlights of his vicious-looking claws and add a few small scales over the finger and toe knuckles.

Step 4:
Using an extra fine pen or nib, ink in the lines of the breastplate.

Step 5:
With the same pen or nib, flick in the lines to depict the feather effect in the tail. Now for the colour…

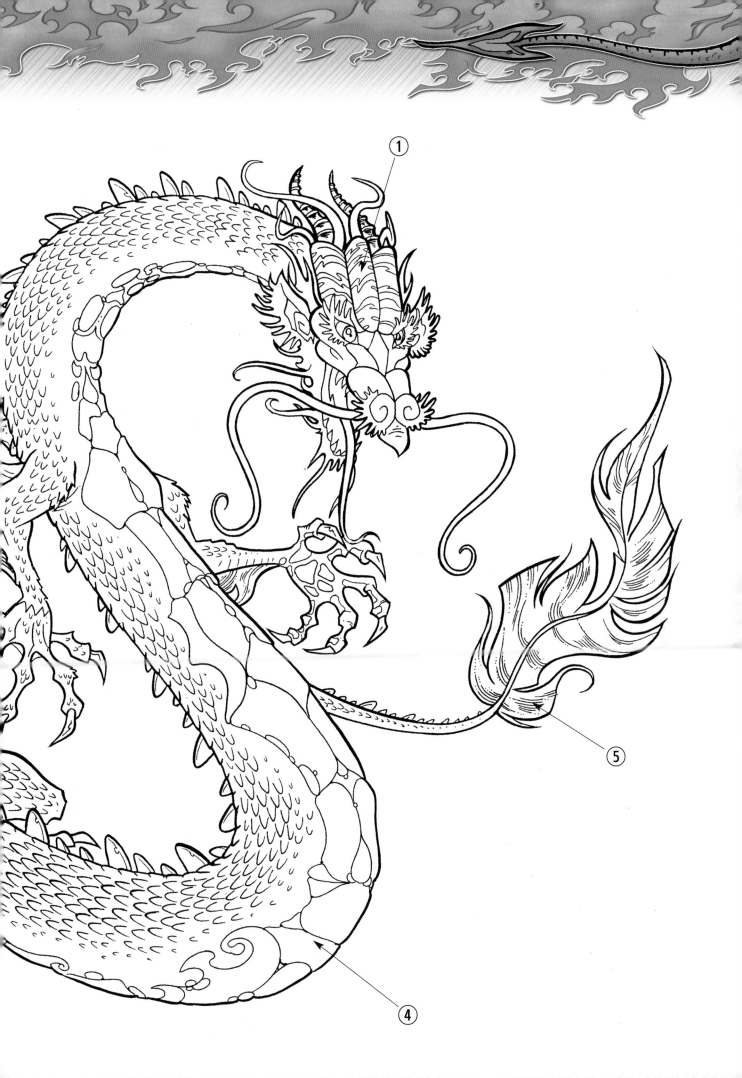

Eastern Dragon (Tibetan)

STAGE 7

Step 1:
The curved body of this handsome dragon is the colour of polished gold. In the moonlight, the scales shine with an eerie glow.

Step 2:
The back spines are a dullish khaki, and made of the same substance as rhinoceros horn.

Step 3:
The fingers and toes have a green tinge to them, while the claws – which are exceptionally sharp – are a gunmetal colour.

Step 4:
The breastplate scales are fairly thick, enabling the dragon to glide over very rough terrain.

Step 5:
The tail feathers, plus those on the limbs, have a deep, turquoise hue that is quite a contrast to the colour of the dragon's scaly skin. The nose and eyelashes are the same turquoise colouring.

Step 6:
The headplates have a mottled, turquoise sheen to them.

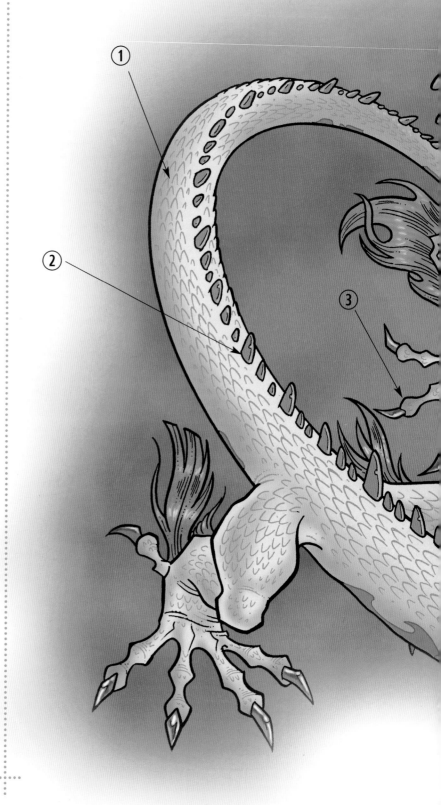

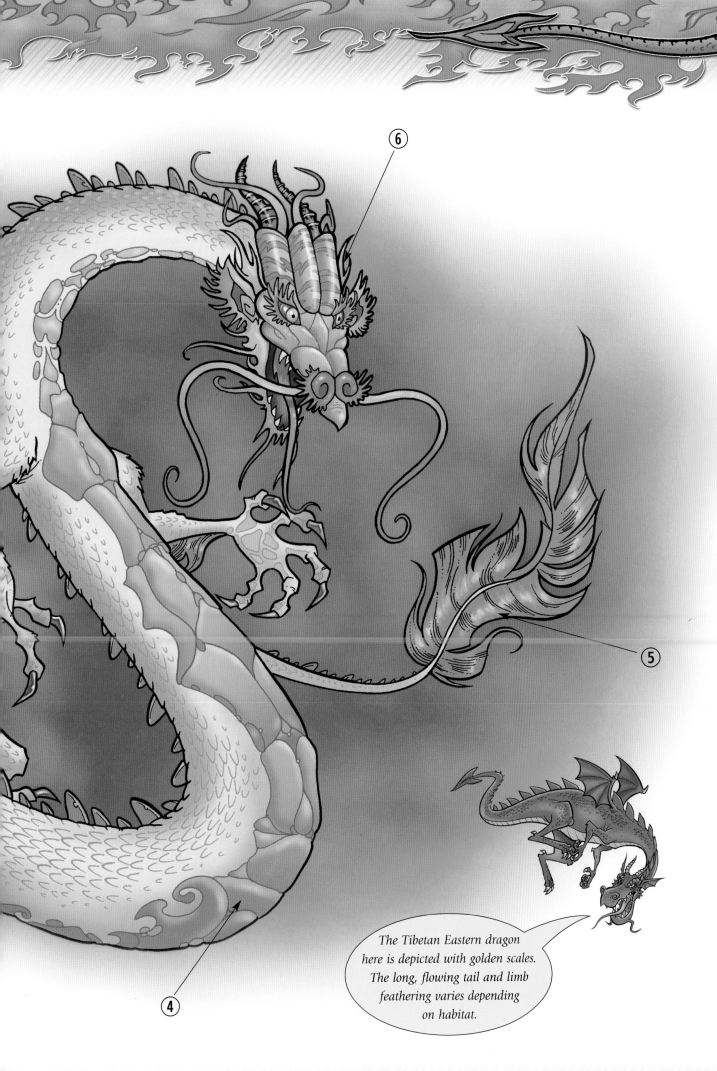

The Tibetan Eastern dragon here is depicted with golden scales. The long, flowing tail and limb feathering varies depending on habitat.

Eastern Dragon (Asian)

STAGE 1

Step 1:

With a deft sweep of your hand, draw in the central flowing line that will decide the position of your dragon.

Step 2:

Now add the two circles for the head; a larger one for the skull and a smaller one for the snout.

Step 3:

Add the forelegs next; a centre circle where the breastbone will be and circles for the elbow joints and the hands. These are joined by lines representing the limbs.

Step 4:

Back legs next, and the same procedure as Step 3: draw the centre circle where the hips would be. The toes are far more spread out than the fingers, and don't forget the dewclaws on the hands and feet.

Step 5:

All done? Now just add a large oval for the end of the tail.

⑤

④

The Asian Eastern dragon (Draco orientalus) frequently features in ancient Chinese art, architecture, literature and folklore.

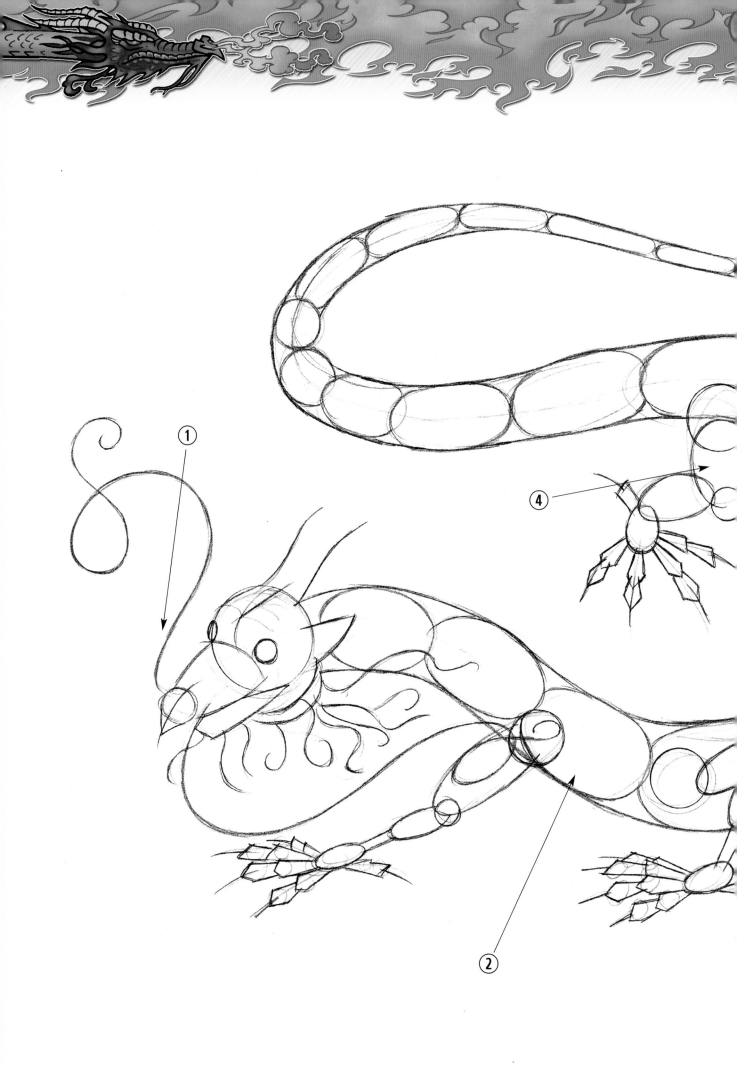

Eastern Dragon (Asian)

STAGE 2

Step 1:
Start to build up the head, drawing lines to indicate the horns, whiskers and flowing hair. Establish the jaws and start to shape the nose.

Step 2:
To guage the thickness and 'feel' of the dragon's body, draw almost egg-shaped ovals. Imagine they're solid, which will help when 'fleshing out' at detailing stages.

Step 3:
Use different shapes and sizes of ovals to build the bulk of the forearms. Use triangles for the toes of this species, as the knuckles aren't as round as the Western dragon's ones.

Step 4:
The legs are much stronger than the forearms, with more bulky muscle, so the ovals for these are much 'rounder' to give them a feeling of strength.

Step 5:
As the tail narrows towards what will be a feathery end, so the ovals become more stretched, looking more like sausages than eggs.

5

3

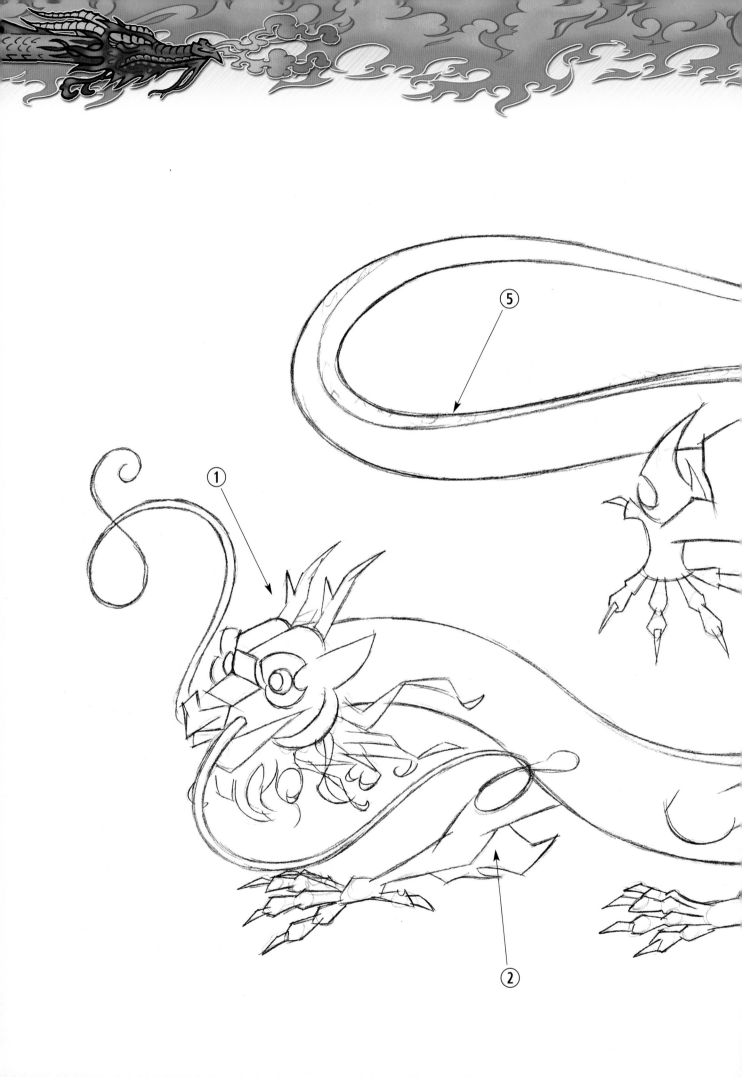

◇Eastern Dragon (Asian)◇

⑥

④

③

Eastern Dragon (Asian)

STAGE 3

Step 1:
Add definition to the flowing hair under the jaw and the cheeks, the thick, feathered lashes around the large, oval eyes and deer-like horns.

Step 2:
Build up the forelegs with sharper straight lines, going over your ovals and circles. Indicate where the leg feathers will appear.

Step 3:
Define the outer body shape and add a line down the centre of the back. This will be your guideline for the back ridge along which this dragon's large scales will run.

Step 4:
Again, with straighter lines, build up the shape of the hind legs and, here too, add your rough design for the leg feathering.

Step 5:
Note how the back ridge is angled in such a way that, at various points, we see both sides of the beast's body.

Step 6:
Start to shape the tail feathers. You should still be drawing very sharp, angular lines at this stage.

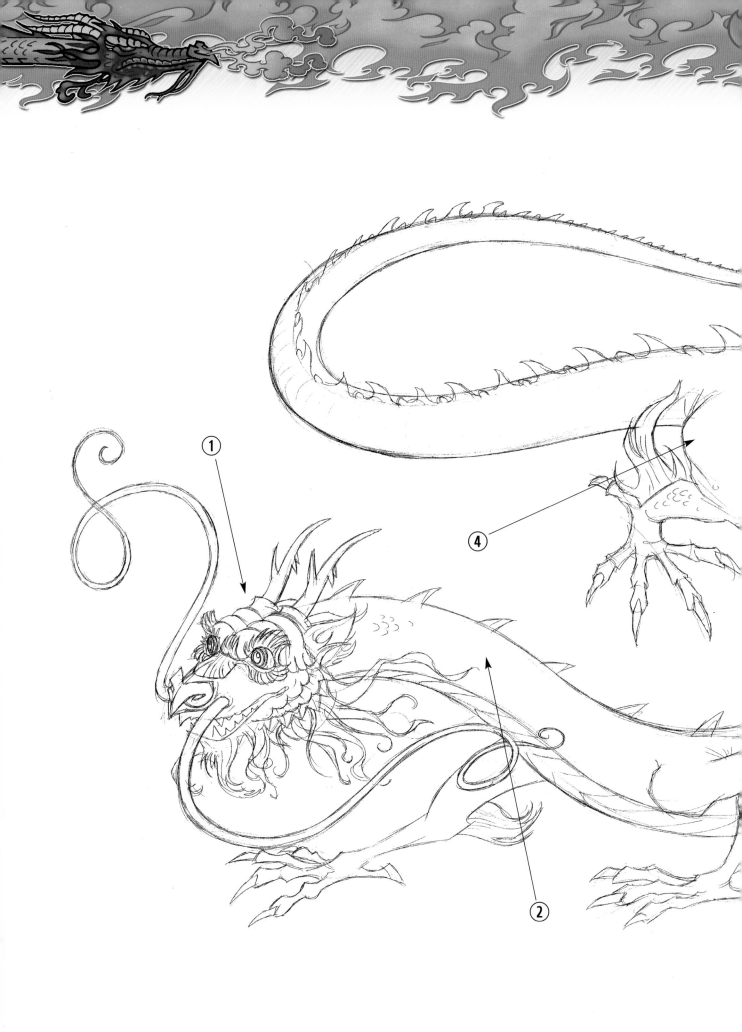

⑤

③

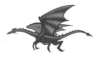

Eastern Dragon (Asian)

STAGE 4

Step 1:
The head is almost there now. Draw the pupils in the eyes. Add the bumps on the top of his skull and start to build up the detail on the hair around the eyes, cheeks and jaw line.

Step 2:
Following your backbone line, roughly indicate the large back scales. These are widely spaced near the head, but merge to a continual line as we work our way down the back to the tip of the tail.

Step 3:
Bearing in mind how the dragon's body twists back on itself, mark in the scale lines of the underbelly.

Step 4:
Build up the muscle definition in the forearms and hind legs, not forgetting the hands and feet.

Step 5:
The tail feathering is taking shape, too. Draw in a combination of single and bunched strands of hair.

◇Eastern Dragon (Asian)◇

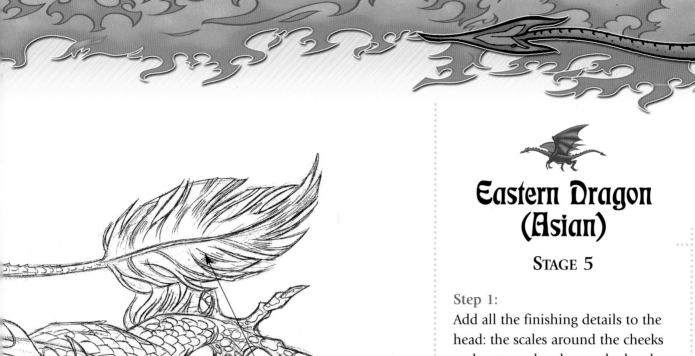

Eastern Dragon (Asian)

STAGE 5

Step 1:
Add all the finishing details to the head: the scales around the cheeks and patterned scales on the head. Draw in the teeth in more clearly and do the same for the eyes.

Step 2:
Finish the forelegs and toes by adding scales of different sizes as they descend from the shoulders. Add detail to the hair on the arms.

Step 3:
Cover the whole body with 'squarish' scales. Asian Eastern dragons have fish-like scales, as opposed to the armour-like, triangular scales of Western dragons.

Step 4:
As with the forearms, the scales on the hind legs diminish in size as they descend towards the toes. They also follow the contours of the muscles.

Step 5:
Finish off the large ridge scales on the back.

Step 6:
Add a few lines in the centre of the tail feathers to give the appearance of a slight sheen.

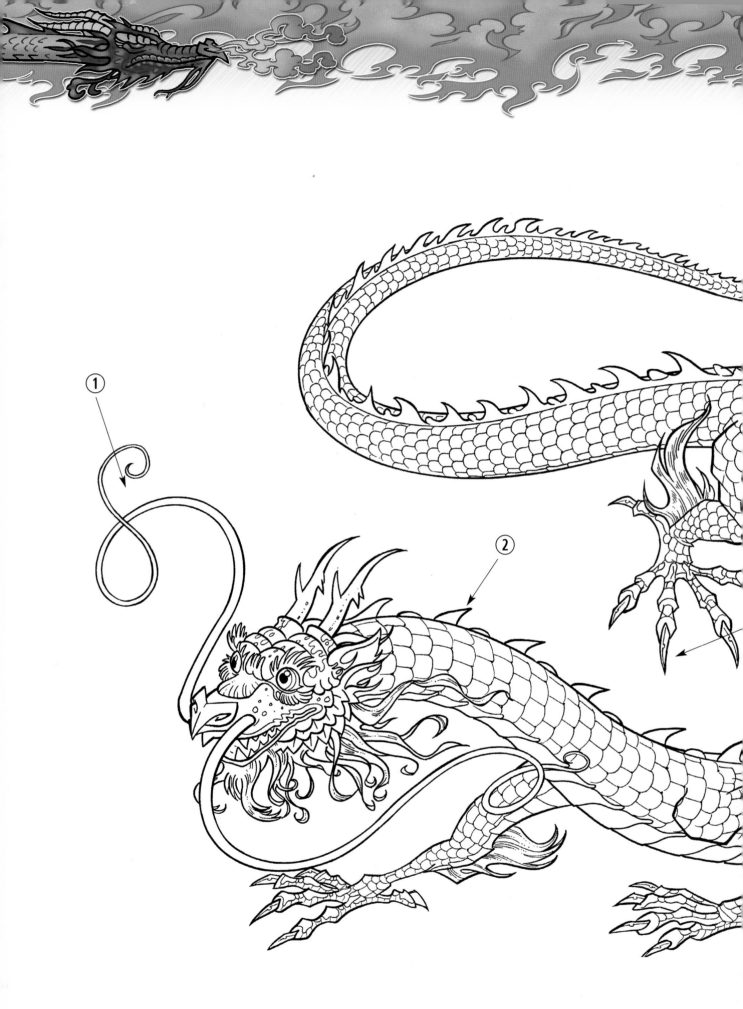

①

②

◇Eastern Dragon (Asian) ◇

Eastern Dragon (Asian)

STAGE 6

Step 1:
The whiskers are the trickiest to ink. Trying to keep a steady hand while maintaining a smooth line over a relatively long curve can take quite a bit of practice! Again, French curves certainly help.

Step 2:
The main outline of the body is drawn with a thicker line. Try a watercolour brush or a thick, felt-tip pen.

Step 3:
The upper-body and underbelly scales are inked with a fine-nibbed pen. This stage may take a while to finish, but it has to be done…

Step 4:
Still with the fine-nibbed pen, ink in the highlights on the claws on both the hands and feet.

Step 5:
The tail feathers look as though they're glossy, as do the rest of the dragon's feathers. This will be emphasized even more once the colour is added at the next – and final – stage.

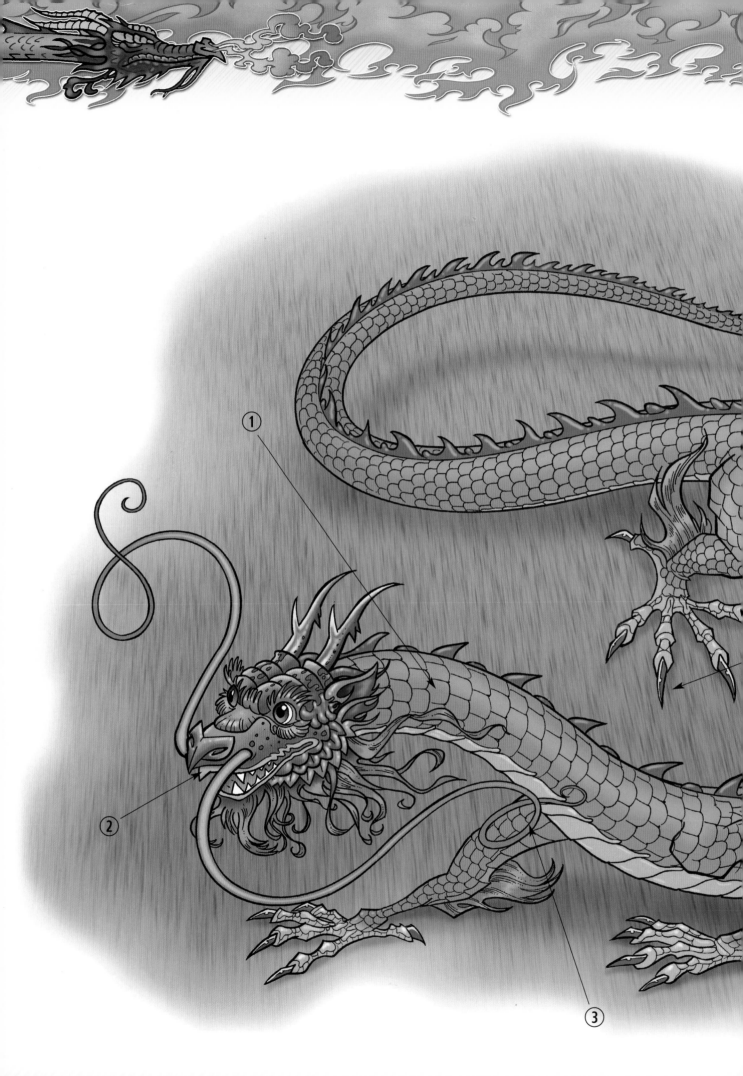

Eastern Dragon (Asian)

STAGE 7

Step 1:
The main body of the Asian Eastern dragon is a deep fiery red-orange with a subtle satin sheen, which ripples along the animal's body as it moves.

Step 2:
The lips are light blue, as are the eyelashes, which have a silky sheen to them.

Step 3:
The long, curling whiskers start red, but take on a blue tinge towards the end.

Step 4:
The fingers and toes are slightly paler than the rest of the body, and the claws are the same colour as the horns since they're made of the same substance.

Popular colours for this good-looking dragon are usually red or black, though green is quite common too. You can experiment though – don't be too tied to tradition.

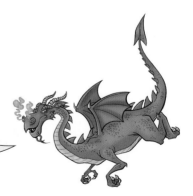

Eastern Dragon (Mongolian)

STAGE 1

Step 1:
Start by drawing one fairly large circle, slightly overlapped by a smaller oval.

Step 2:
Then, paying particular attention to the flow of the centre line, sketch it in, adding a loop or two.

Step 3:
Draw a slightly curved line across the centre line of the dragon, a short way down from the head. Add small circles to indicate where the shoulders, elbows and wrists will be.

Step 4:
Sketch in a distorted oval for the palm of the hand and add curved lines from which the fingers will spread out.

②

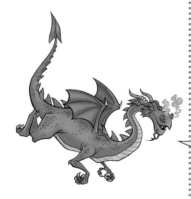

The Mongolian dragon (Draco serpentalis) is certainly the most snake-like of all the Eastern dragons – and the most dangerous.

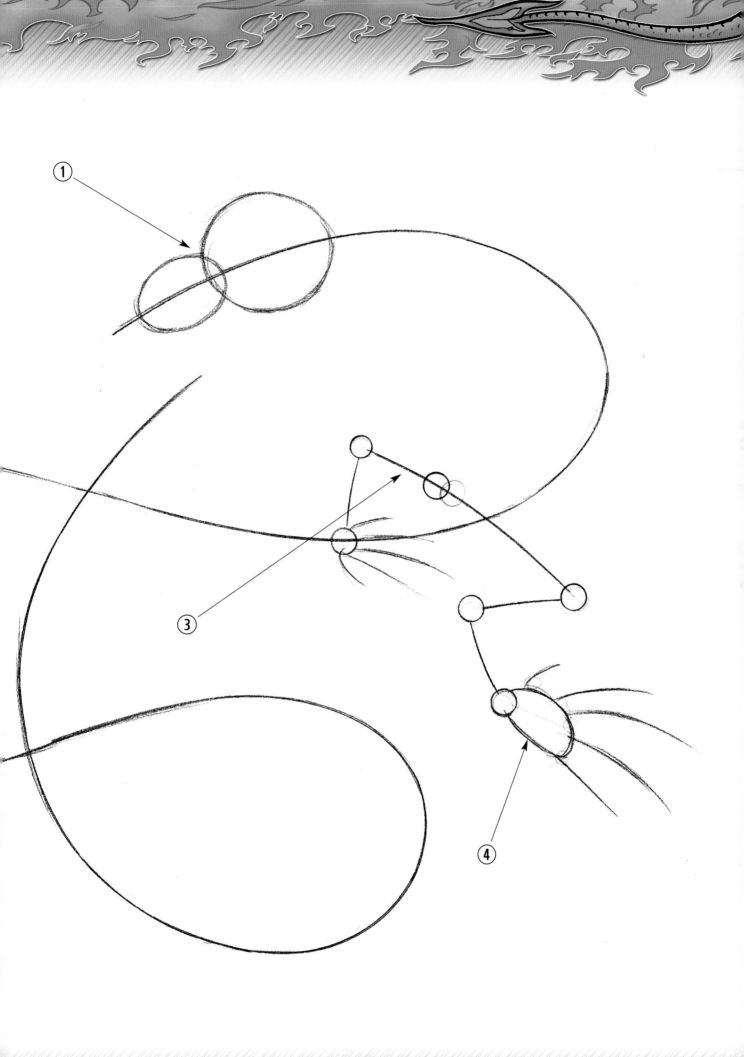

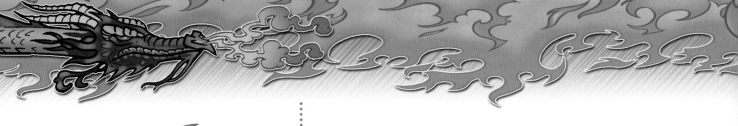

Eastern Dragon (Mongolian)

STAGE 2

Step 1:
Draw an upwardly curved line to mark the position of the eyes. Add a line from the top of the circle down to the oval, which is the centre of the head. A quick couple of flicks with your pencil and the position of the horns are in place.

Step 2:
Its body consists of a series of ovals progressively getting larger from the neck to the main body and then reducing again as they travel down to the tail. Note that where the perspective of the body is flat-on the ovals become circles.

Step 3:
A rough, spear-shaped oval should be added to indicate the tip of the tail.

Step 4:
Two slightly squashed circles are added for the shoulders, while the arms at this stage are drawn as cylinders.

Step 5:
Now draw the outer shape of the dragon using the ovals and circles as a guide.

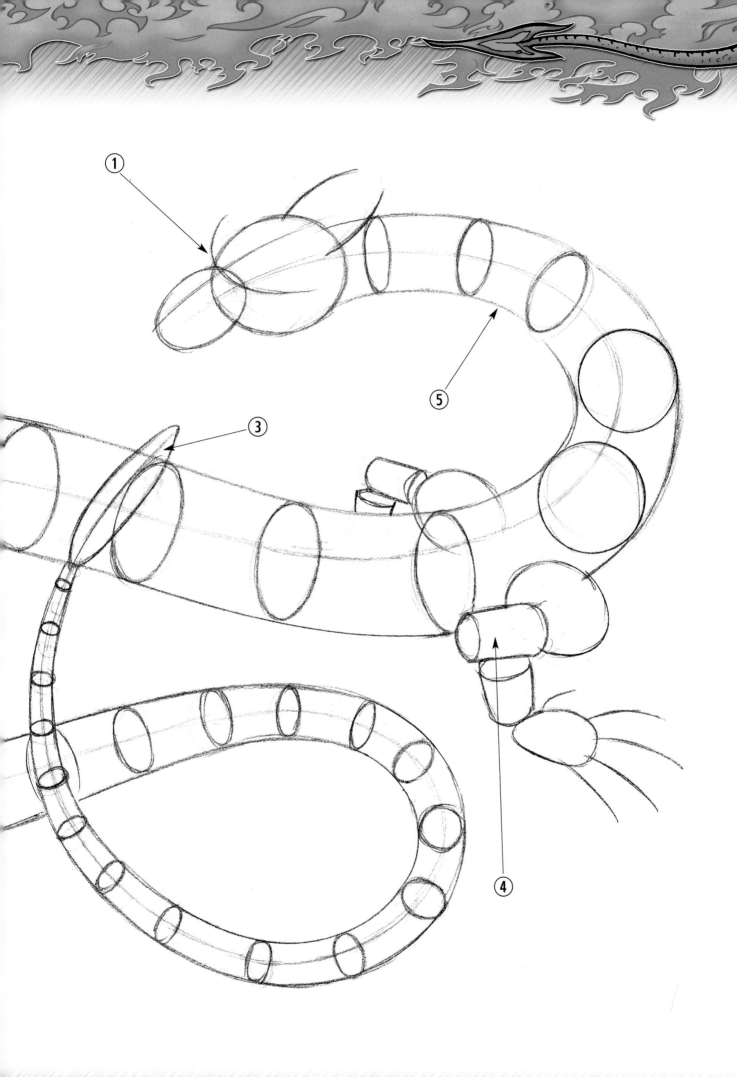

Eastern Dragon (Mongolian)

STAGE 3

Step 1:
Using fairly angular lines, start to build up the head. Place three small horns on the snout, low brows over the eyes and short, thickish horns at the back of the head.

Step 2:
Now you have the long 'snake' body pencilled in, draw in the back ridgeline, making sure it follows down the centre of the back.

Step 3:
Start to shape the triangular, spear-like tip of the tail. Add a couple of little triangles, which will be horny spikes growing out either side of it.

Step 4:
With straight, angular lines, build up the powerful arms, hands and claws. The fingers are divided up into two sections, or joints, each, and so is the thumb.

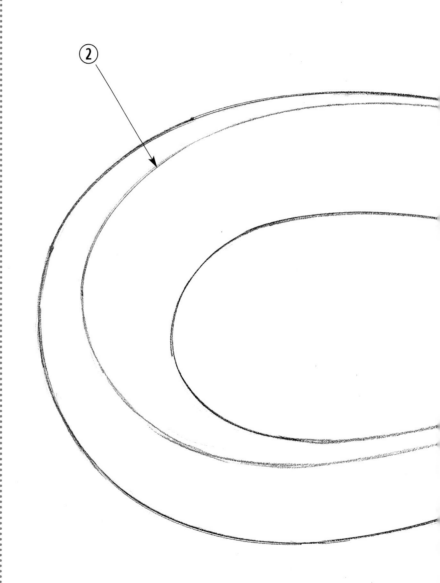

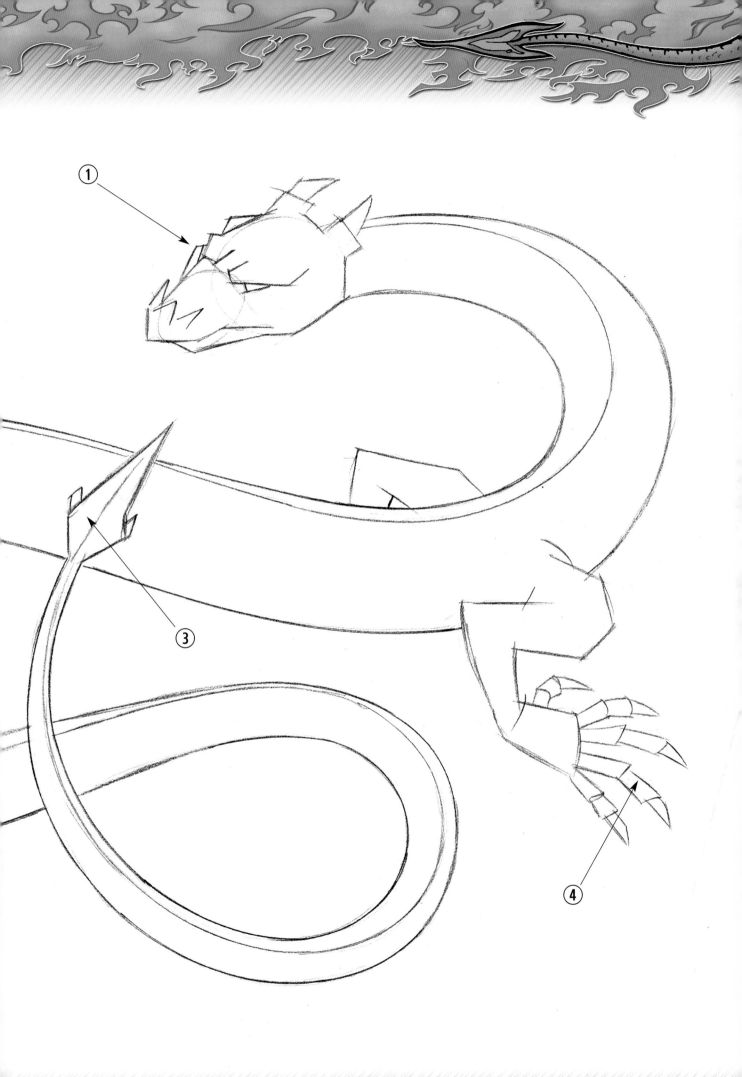

Eastern Dragon (Mongolian)

STAGE 4

Step 1:

The evil head is really starting to take shape now. Add fringe-like lashes to the lower lids of the eyes, nostrils behind the snout horns and start to build up the spike-like scales on the head.

Step 2:

Following the backbone line, draw smallish, stone-like spines all the way down the back. As they descend towards the tail they naturally start to diminish in size.

Step 3:

Soften the lines on the spear-like tail end, add a ridge down the middle and build up the two spikes protruding out of the base.

Step 4:

Add a couple of hard scales to the back of the elbows, wrinkles at the wrist where the arm and hand are at right angles to each other, and build up the fingers.

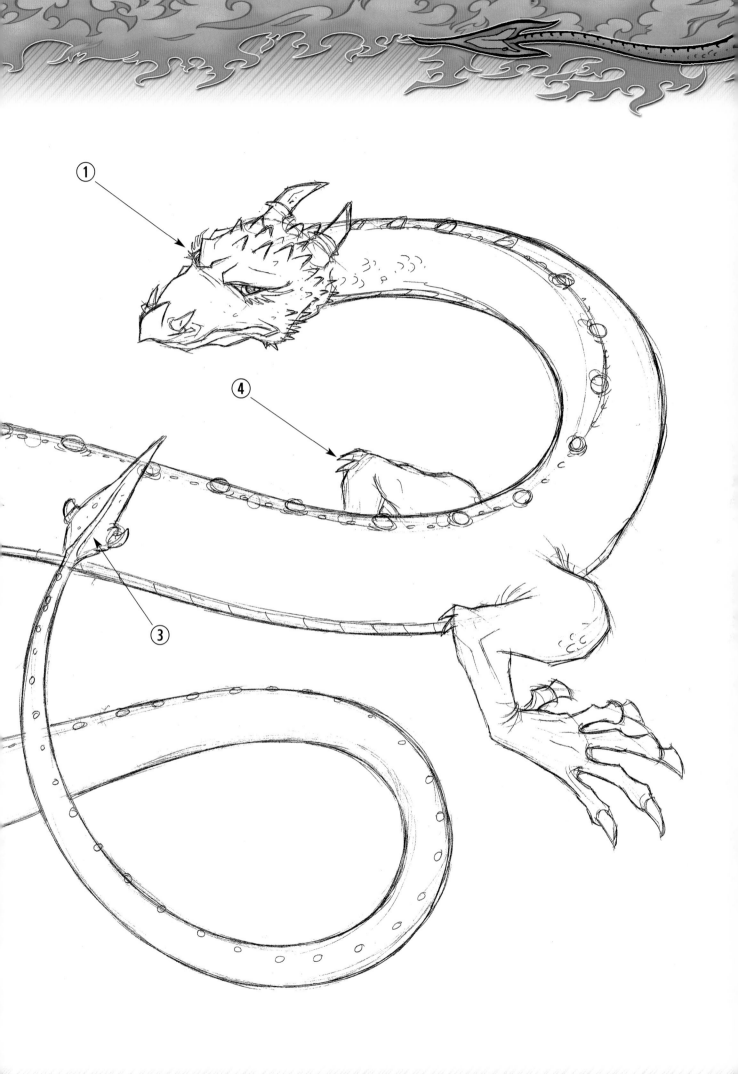

Eastern Dragon (Mongolian)

STAGE 5

Step 1:

We're now at the finished pencil stage. Put in a leathery wisp of skin hanging down from his jaw. Add pupils to the eyes, plus a few lines under them and around the corners of the mouth to depict folds of skin.

Step 2:

Add a couple of smaller scales between each of the larger pebble-like ones on the dragon's back. Cover the whole body with v-shaped scales. Remember, these diminish in size as they travel down the body.

Step 3:

Draw in the tendons that run along the backs of the hands and add little lines around the fingers – this gives a dry, leathery look to the skin. The claws are extended, too, as befits such a ferocious beast.

Step 4:

Add a small, sharp hook to both shoulders and draw in the scales sticking out along the edge of each curved part of the dragon's body.

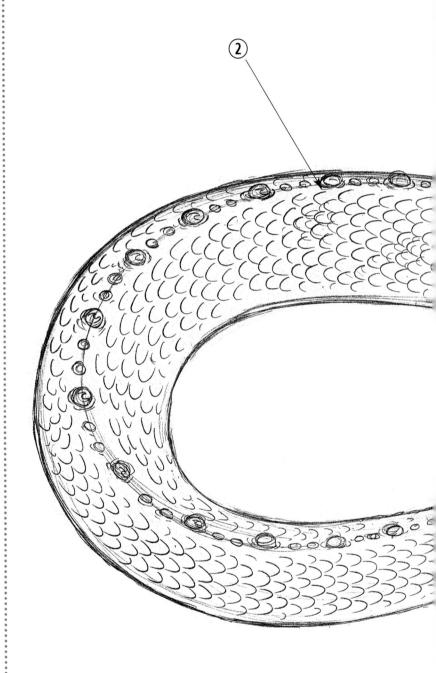

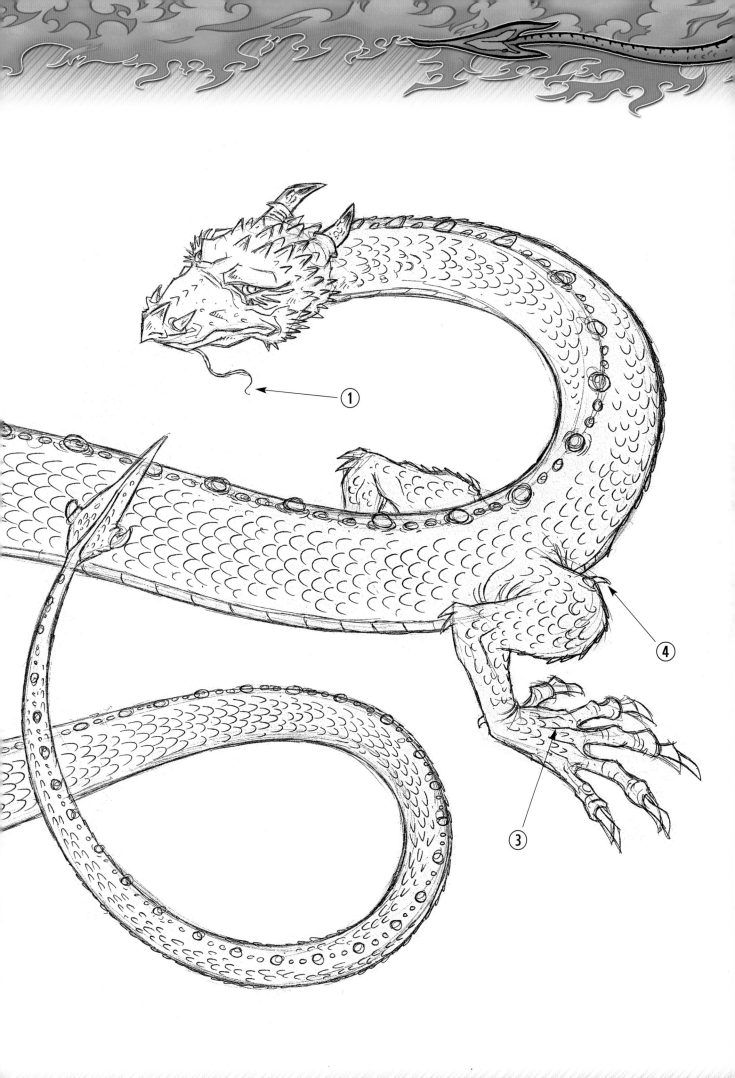

Eastern Dragon (Mongolian)

STAGE 6

Step 1:
Ink in the outline of the head with a fairly thick line, except where there's finer detail such as the feathery eyelashes and the leathery under-chin whiskers. A lighter line is used when inking in the facial scales.

Step 2:
The whole of the outer shape of the dragon is inked with a fairly strong line, though a finer line should be used for the breastplates and scales.

Step 3:
The outline of the tail tip is thicker than the rest of the drawing as it's nearest to us – this helps to make it stand out more.

Step 4:
The same principle applies to the arms and hands: use a strong outer pen-line, and a finer one for the scales and wrinkles.

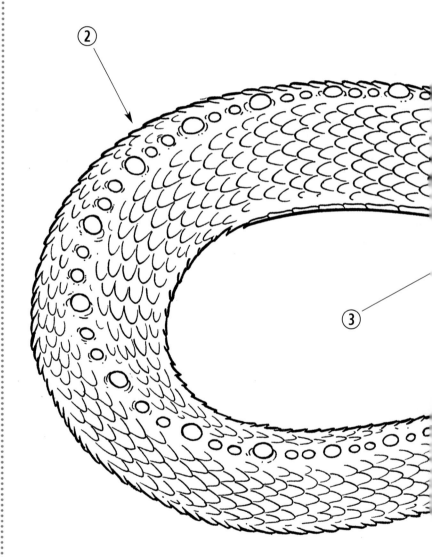

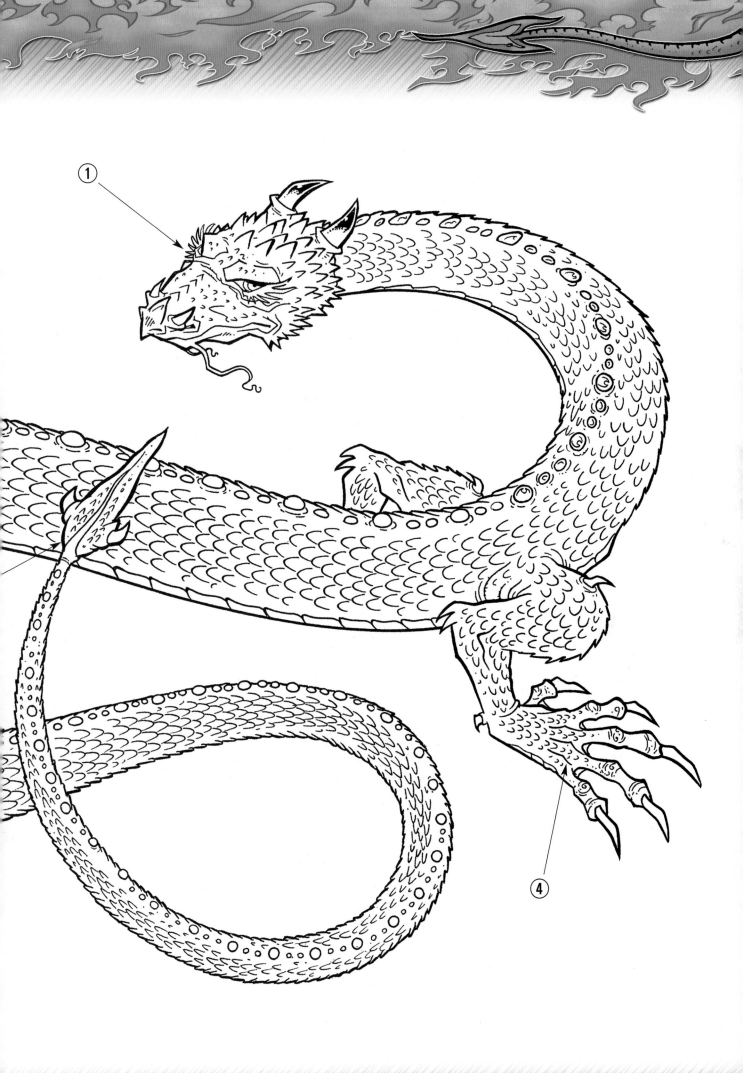

Eastern Dragon (Mongolian)

STAGE 7

Step 1:
The head of this evil-looking dragon is an olive green with dark grey, polished horns.

Step 2:
The body is a metallic blue, though it has a greenish hue to it when the sunlight reflects off its scales.

Step 3:
The sharp, spear-like tail tip is the same colour as the head, and is quite a formidable weapon. It is used to stab and slash at its prey, and at people (they are its only enemies).

Step 4:
Its grey claws are extremely sharp and as strong as iron. These are used to grip its prey and tear the carcass apart.

Step 5:
The belly scales are armour-plated, for the hard ground of the Mongolian steppes can become frozen solid at times.

Step 6:
The rivet-like scales that run down the dragon's entire back glow a dull yellow in the dark, while the rest of the body is all but invisible.

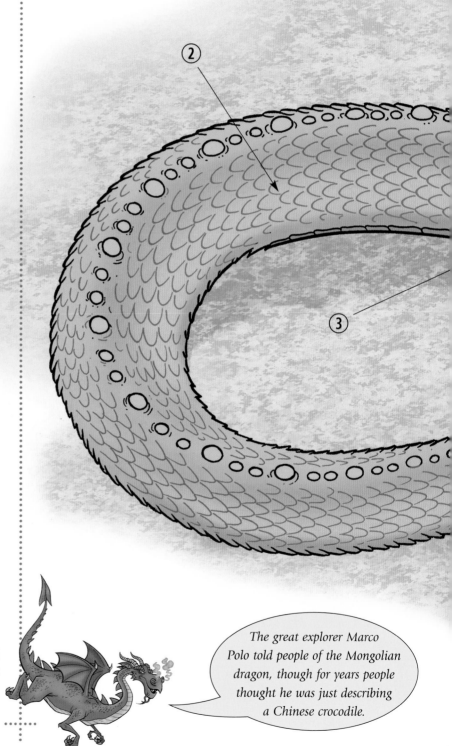

The great explorer Marco Polo told people of the Mongolian dragon, though for years people thought he was just describing a Chinese crocodile.

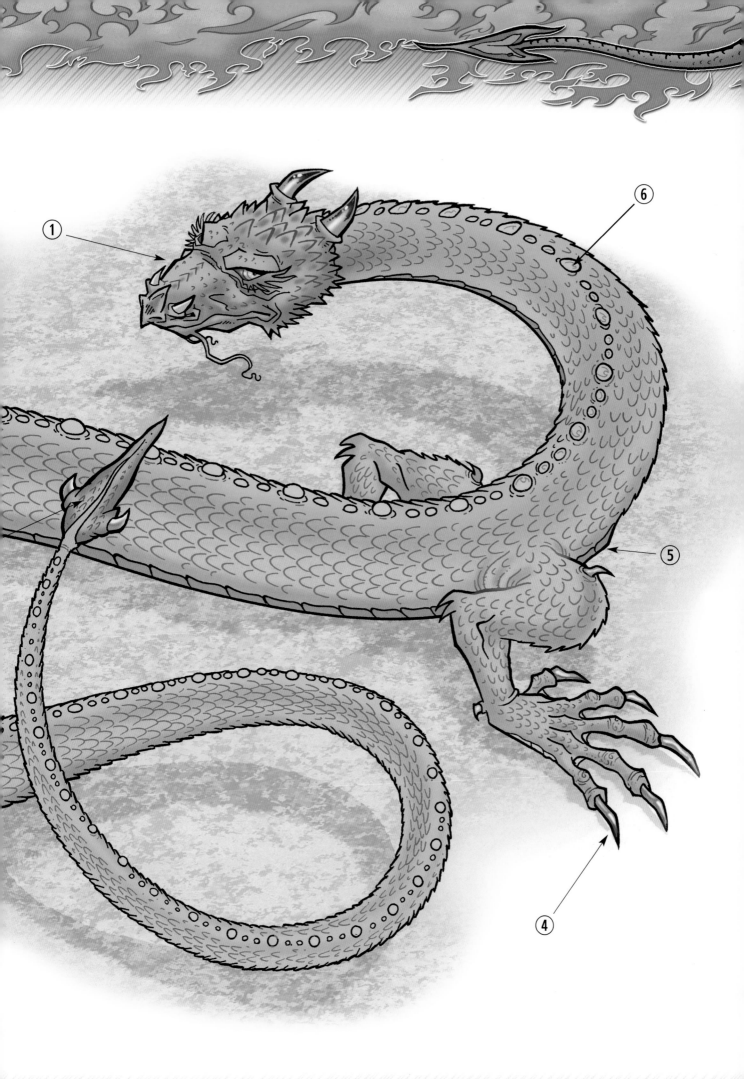

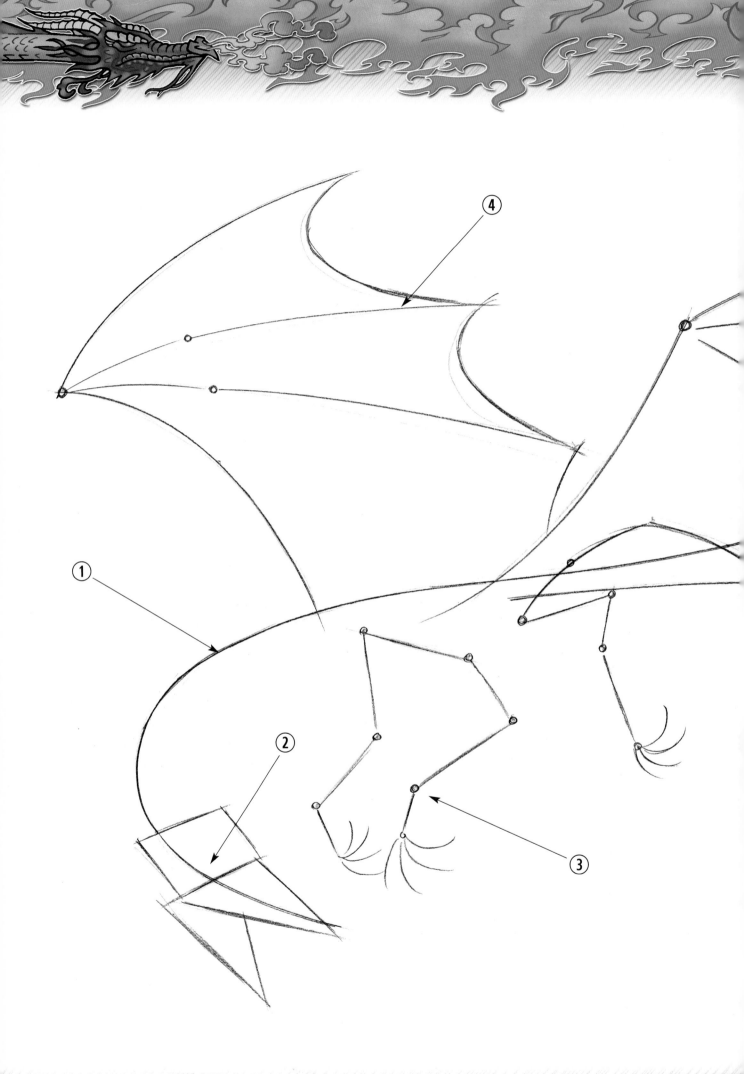

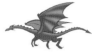

North American Dragon

STAGE 1

Step 1:

You should be getting the hang of this by now. Have a think about how you would like your dragon to fill the page and then pencil in your 'centre line'.

Step 2:

Add a rectangle for the skull and two triangles for the upper and lower jaws.

Step 3:

As you now know, the easiest way to start a drawing is by pencilling a stick figure – this way you can develop your drawing before putting too much effort in it. Use dots for the joints and straight lines for the limbs.

Step 4:

Roughly shape in the wings, placing dots where the joints will be and then adding single lines for the 'hand' struts of the wings, which are always positioned where the shoulder blades are. Even when sketching at this early stage, always 'draw through' – this enables you to get the proportions reasonably right.

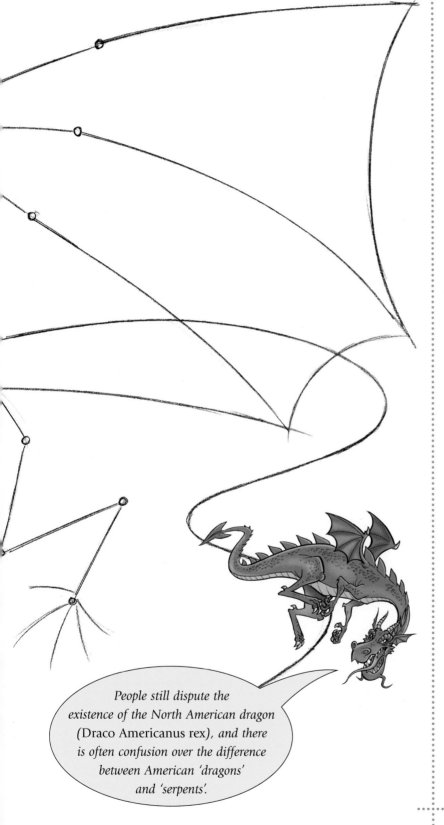

People still dispute the existence of the North American dragon (Draco Americanus rex), and there is often confusion over the difference between American 'dragons' and 'serpents'.

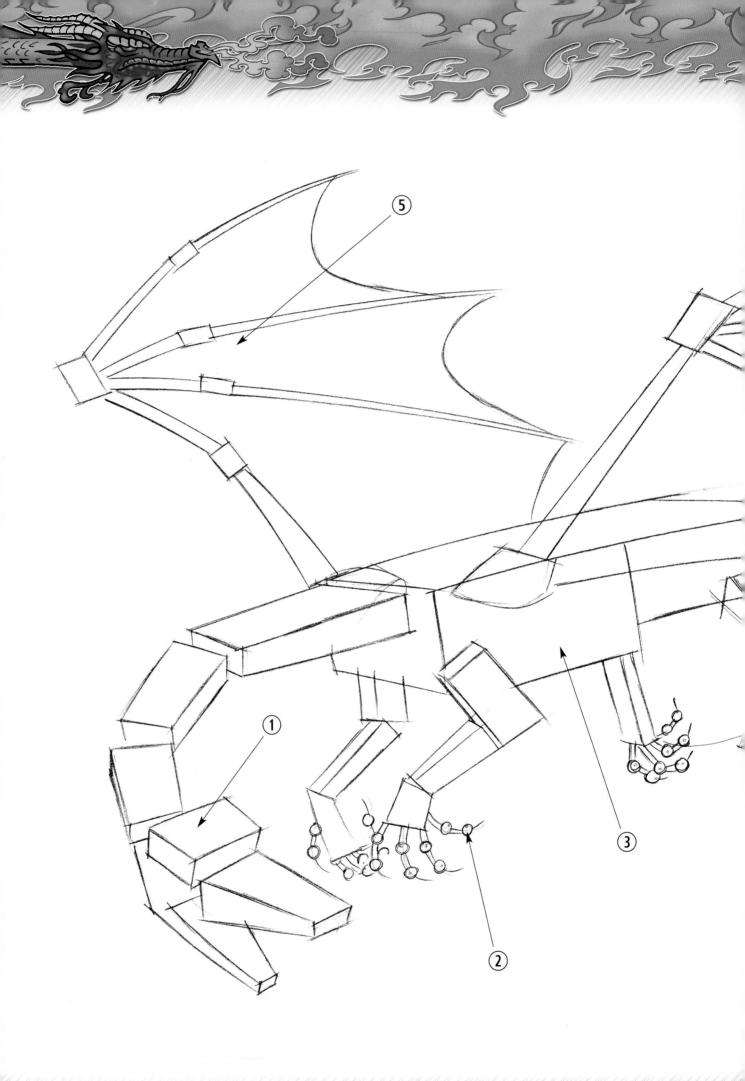

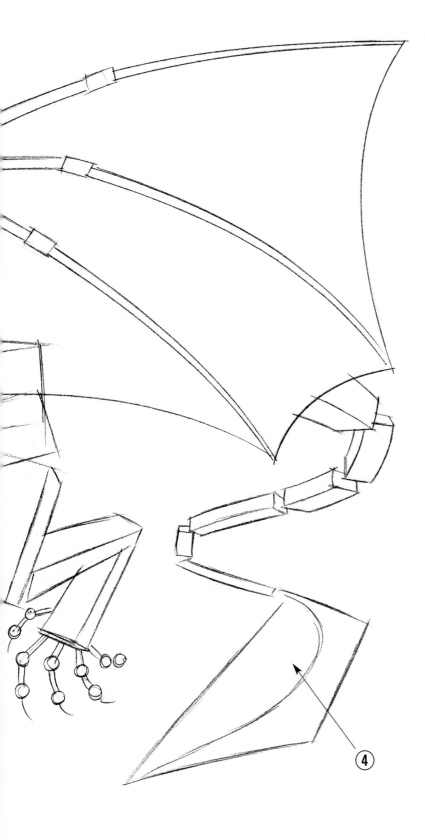

North American Dragon

STAGE 2

Step 1:
Use rectangular blocks to contruct the head and neck, following your 'central line'.

Step 2:
Using the dots and lines previously drawn as guidelines, overlay the blocks for the forearms and hindquarters. The fingers and claws are a little too small for this constructional device, so use the tried and tested circles and curved lines method instead.

Step 3:
For the upper body chest cavity, draw a larger block than the lower hip section. A dragon of this size needs a deep chest and large back muscles to carry its weight in flight.

Step 4:
The tail of this species ends in hard, leathery fused feathers so, to begin, just sketch in the rough shape you would like it to be.

Step 5:
Build up the wing arms and 'hand' supports using blocks over the little rectangles that indicate the joints. Double up your lines on the wing struts to give them body.

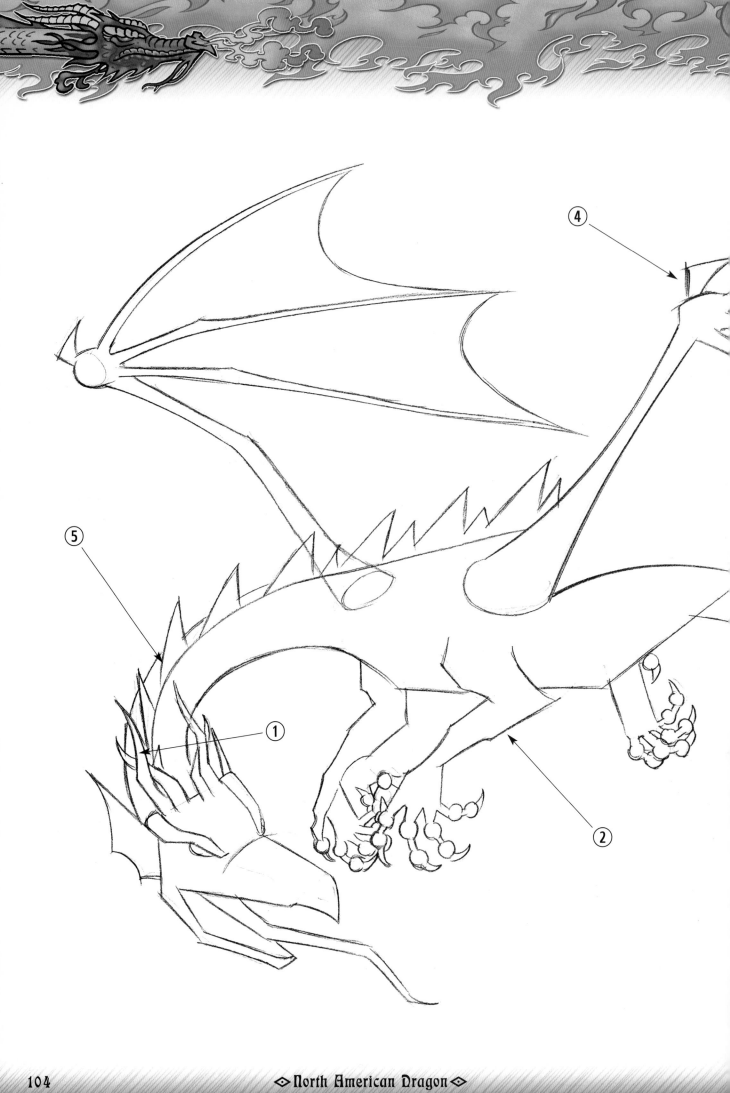

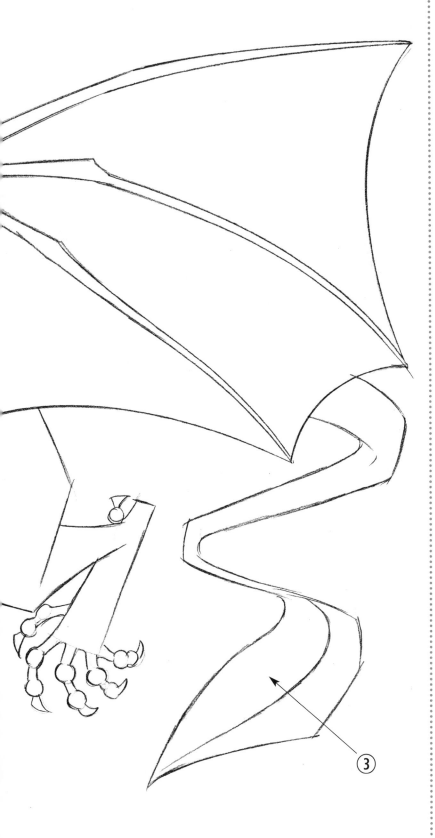

North American Dragon

STAGE 3

Step 1:
Sketch in the four horns on the top of the head, add eyebrow ridges over the eyes, build up the jaws with a long tongue snaking out and, finally, add the ears.

Step 2:
Build up both the forearms and hind legs plus the hands, feet and claws, not forgetting the dewclaws at the back of each hind leg.

Step 3:
Unlike most other dragons' tails, the North American dragon's is rather flat and rectangular and, by using the block technique, it's easy to achieve this shape.

Step 4:
On the top of each wing, sketch in a large claw. Most dragons with leathery wings have these. They're sometimes used as extra weapons, though with sharp talons and teeth, not to mention fiery breath, they're rarely needed!

Step 5:
Draw in the large, triangular scales that run down the spine. On North American dragons they don't continue all the way down to the tail.

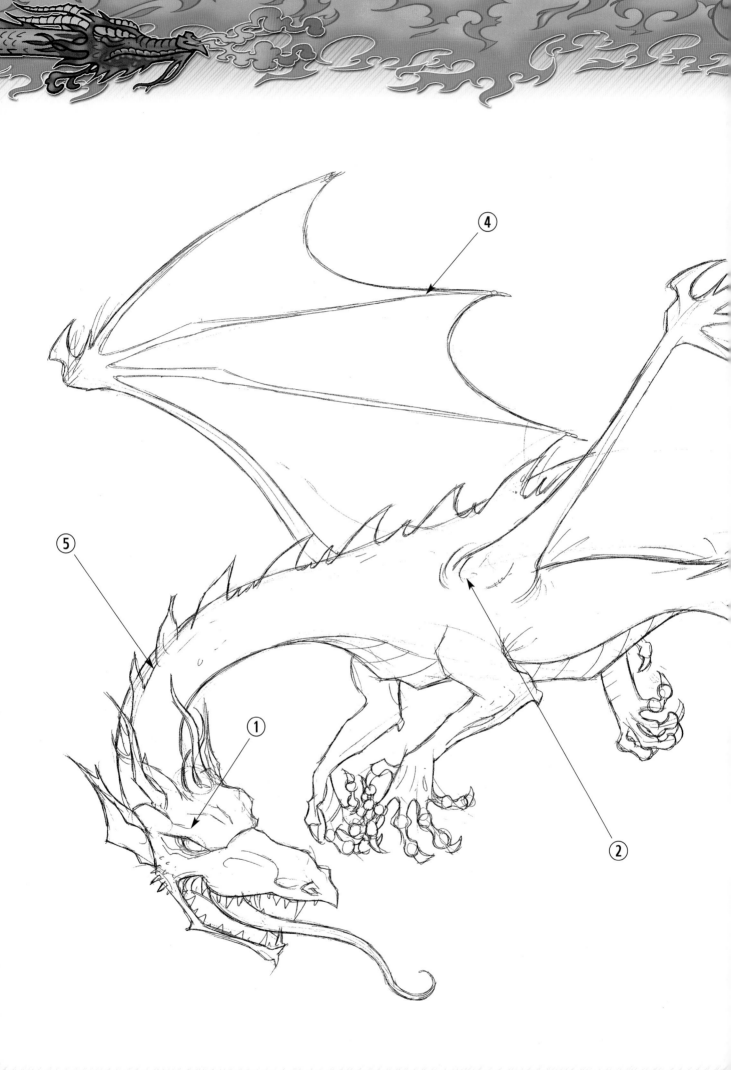

North American Dragon

STAGE 4

Step 1:
Start to build up the contours of the head, which will give it depth and definition. Add the teeth, nostrils and cheek spikes.

Step 2:
Shape the muscles in the shoulders and forearms plus, of course, the hands. Then do the same with the hindquarters.

Step 3:
Develop the leathery tail feather more clearly by adding holes and wear and tear to the edges.

Step 4:
Smooth out the hard edges of the wing joints and those of the two wing claws, then add lines to indicate wrinkled skin where the visible wing joins the dragon's back.

Step 5:
Round off the sharp edges to the back scales, giving them all a backward slant.

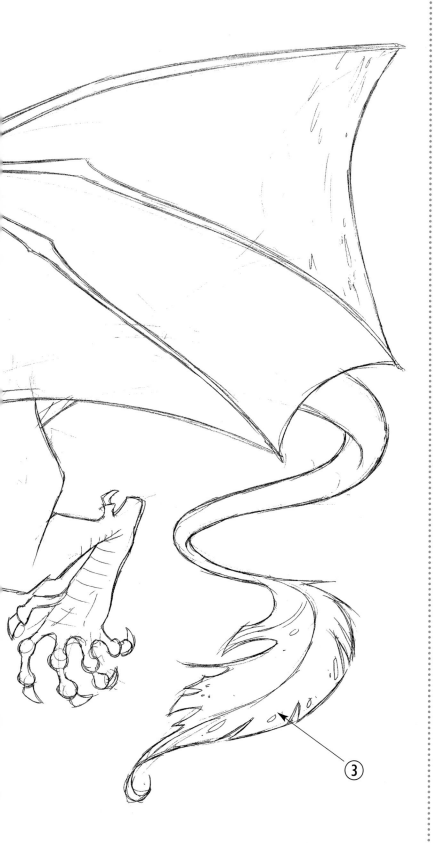

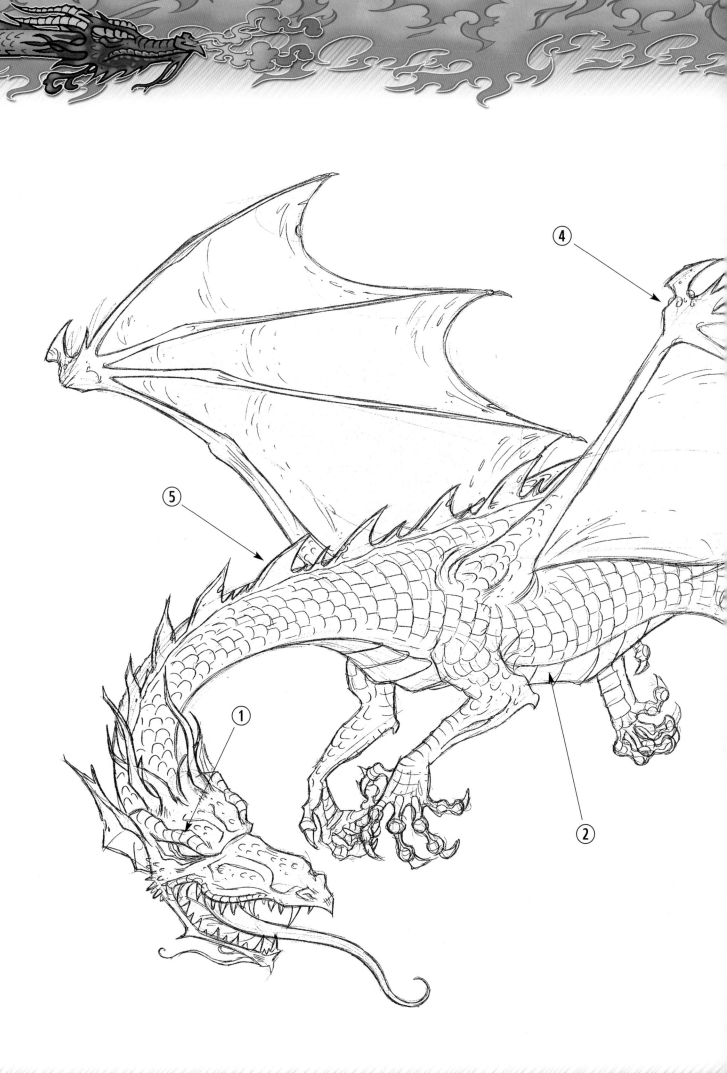

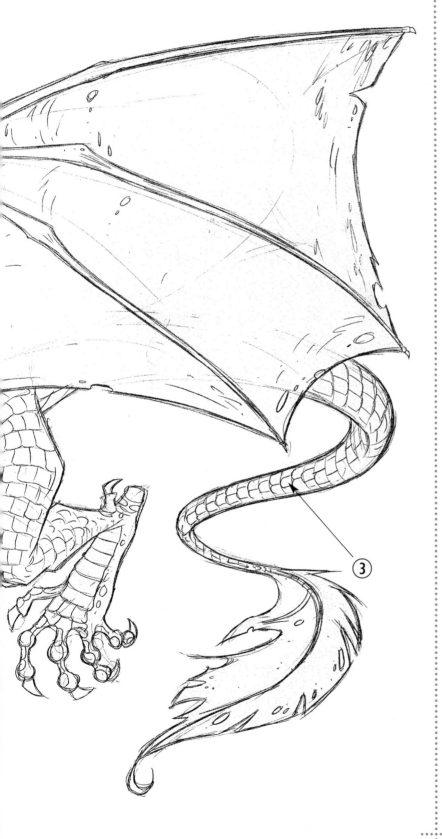

North American Dragon

STAGE 5

Step 1:

Draw in the scales over the eyes and around the mouth. Add two thin, flowing chin whiskers, wrinkles under the eyes and the sharp little facial scales on the head.

Step 2:

Darken up the pencil lines on the underbelly scales and sketch in the scales over the hands and feet. Darken all your pencil lines for clarity.

Step 3:

When you draw the scales on the tail, remember the angle of the scales will change as the tail moves.

Step 4:

Sketch in the bumps, spikes and little claws on the tips of the wings – a few holes and tears in the wing membranes give them a battle-worn look.

Step 5:

The thin lines down the sloping edges of the back scales reveal how thick they are. Overlapping, squarish body scales should now be sketched in, bearing in mind the contours of the dragon's body.

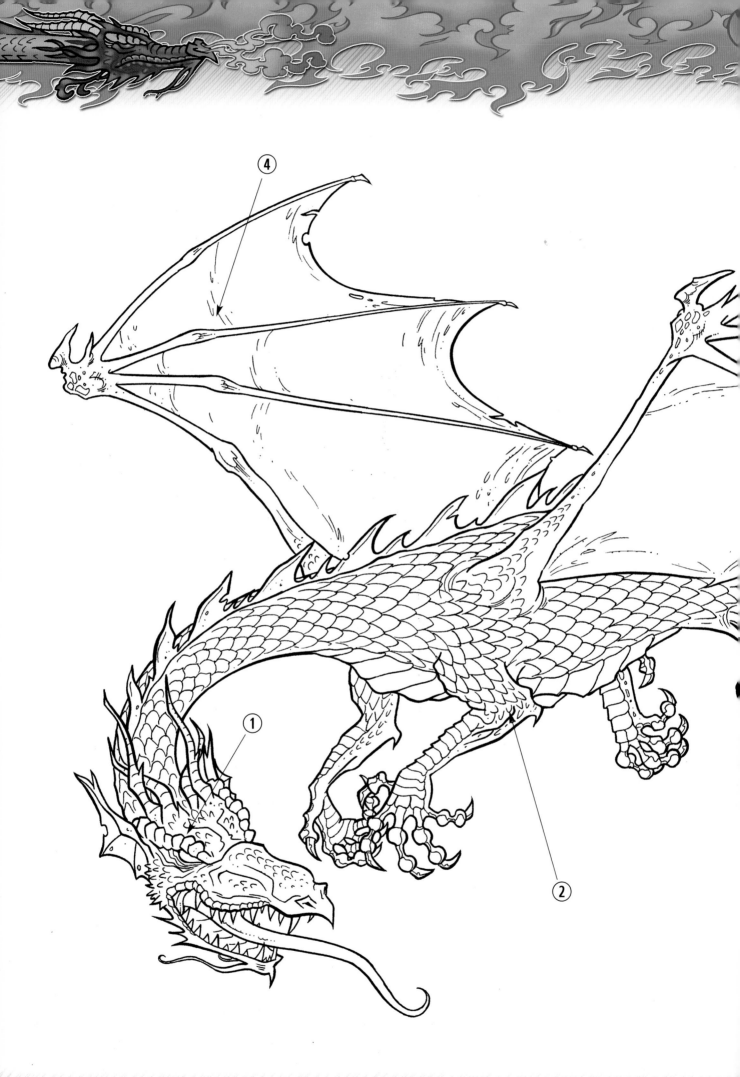

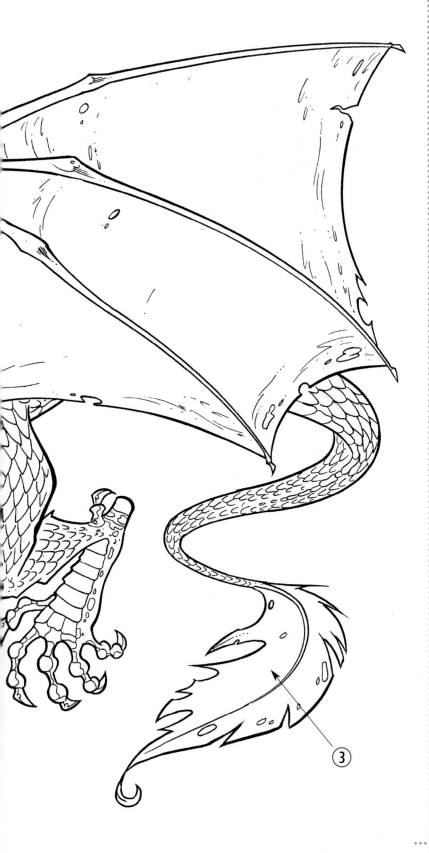

North American Dragon

STAGE 6

Step 1:
Out with your brush pen (or whatever you like to ink in your outline with) and carefully trace over the final pencil lines, starting with the head.

Step 2:
Once the whole basic body is done, use a fine line to ink in the smaller details, such as the scales on the head, hands and feet.

Step 3:
There are no fine lines to depict feathery strands on this tail – it's basically a fused, leathery flap of skin.

Step 4:
Now add fine, thin lines to indicate the stretch of the membrane between the wing 'hands' – add a couple more holes for extra wear and tear, too, if you like. It's not too late to change things at this stage: you'll notice the squarish scales are now triangular, which look much better. Again, the scales become smaller as they descend down the limbs and tail.

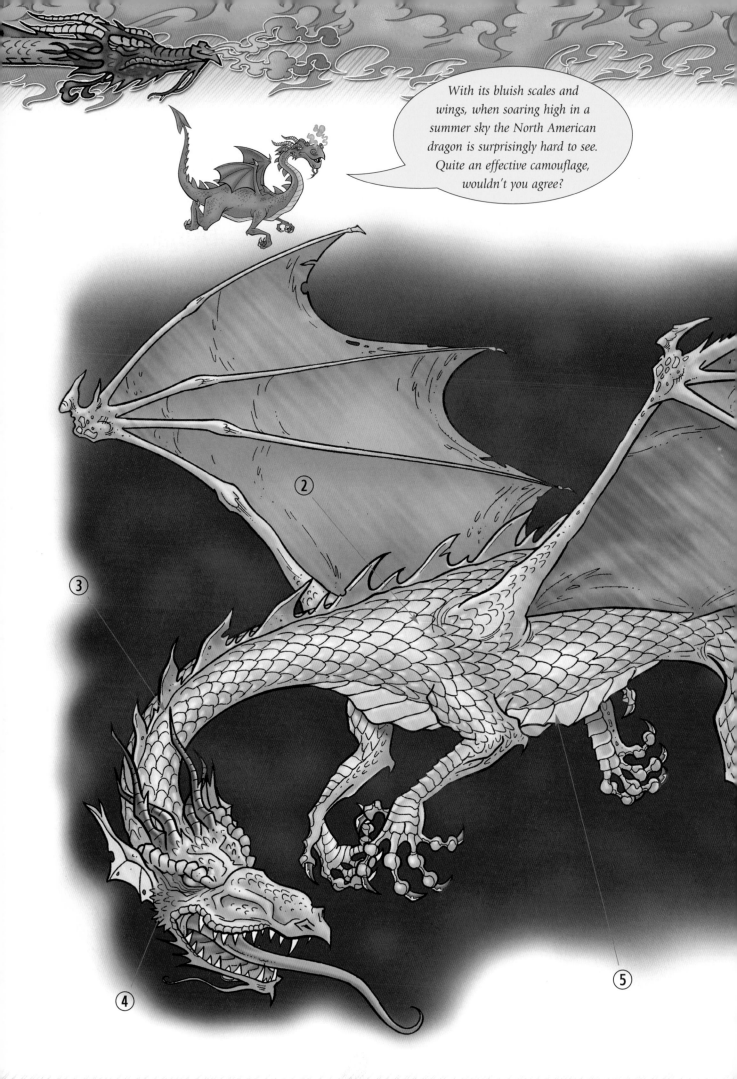

With its bluish scales and wings, when soaring high in a summer sky the North American dragon is surprisingly hard to see. Quite an effective camouflage, wouldn't you agree?

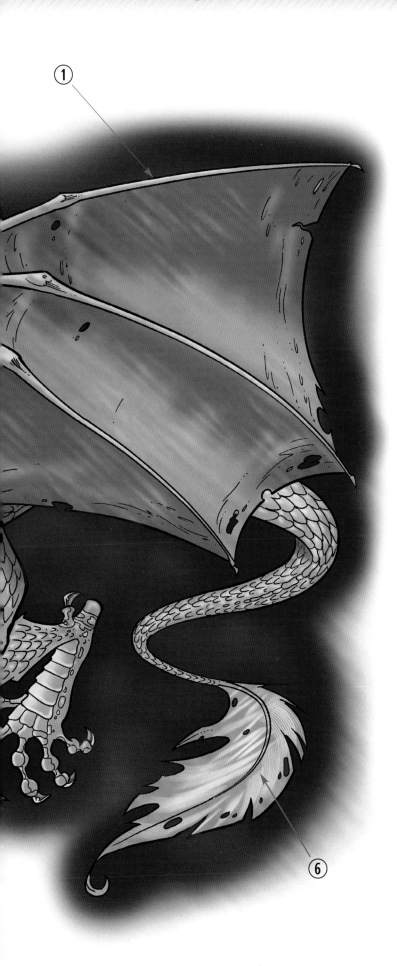

①

⑥

North American Dragon

STAGE 7

Step 1:
The wings of this large dragon are a slightly stronger blue than the rest of its body.

Step 2:
The scales and skin are a metallic blue and almost as hard as metal. On the rare occasions when man comes across a dead dragon he has been known to prize off (with great difficulty) the back scales, rivetting them together to make fine body armour.

Step 3:
The horns are extremely strong and coloured a deep, shiny blue-black.

Step 4:
The eyes shimmer with a fiery glow.

Step 5:
The scales on the underbelly are not as strong as the smaller body scales and, if struck at the right angle, can be pierced by a sharp arrow or spear.

Step 6:
The tip of the tail is made from the same membrane substance as the wings, but the edges are very sharp and can inflict deep cuts to unprotected skin.

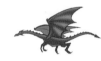

Central and South American Dragon

STAGE 1

Step 1:

Start with the usual long, swirling centre line, which is the foundation on which you'll be constructing your dragon body. At the top, as before, add two circles; a large one for the skull, a smaller one for the snout.

Step 2:

About a third of the way down the 'body', roughly sketch in your two wing shapes. Remember, the Central and South American dragon has evolved feathered wings as opposed to the usual leathery membrane. As they're like birds' wings, they're quite elongated – think birds of prey and 'raptors.

Step 3:

The angle of this dragon looks quite complicated, though it's not really. We're looking directly up at the feet and legs from underneath, so just start with a line to either hip, circles at the joints, lines to the knees, another circle, lines down to the heels, more circles, and lines to the end of the foot.

Step 4:

Three quick dashes of your pencil to each foot to mark the positions of the elongated toes.

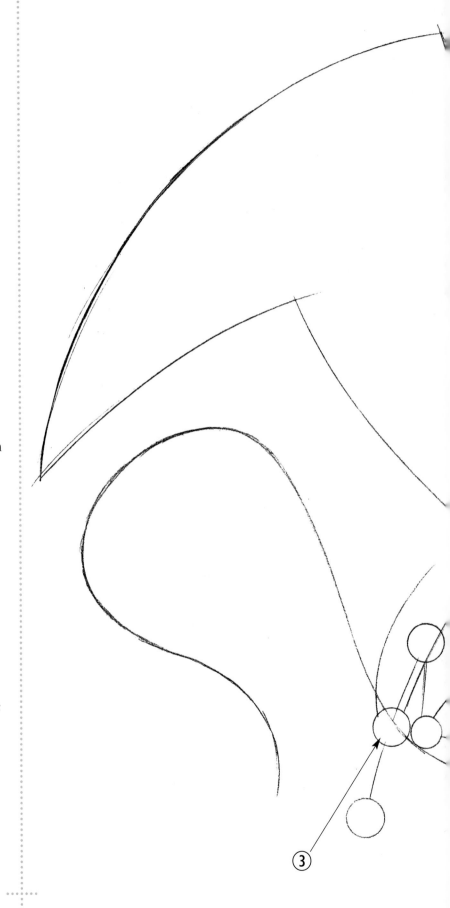

③

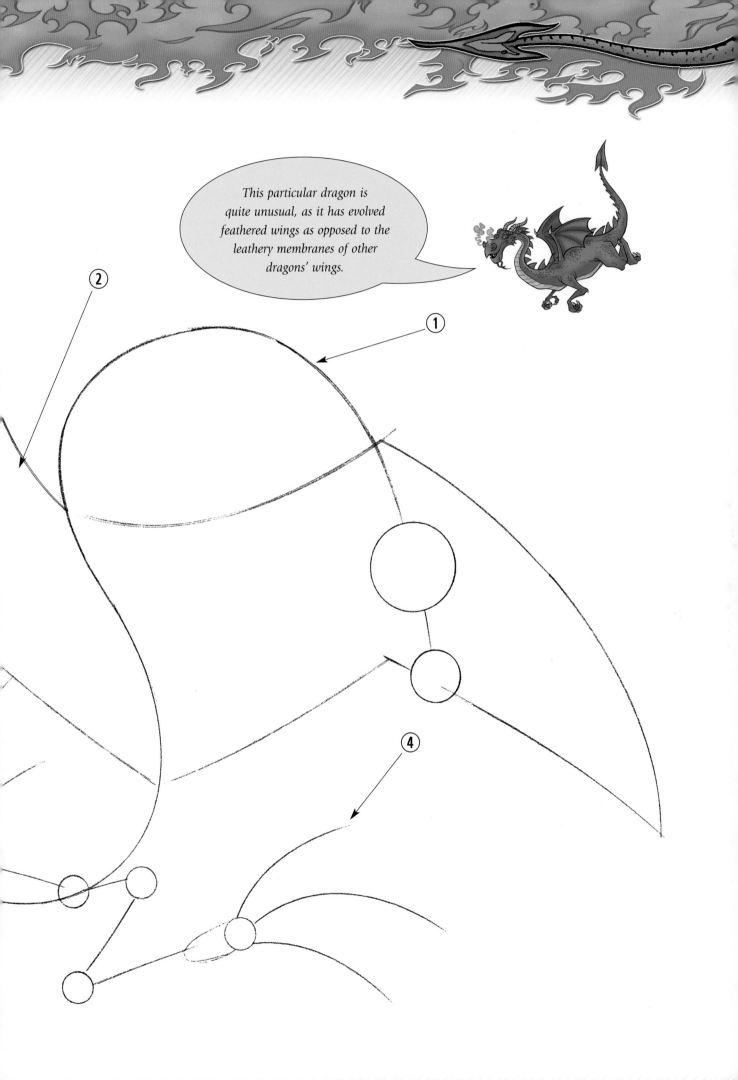

This particular dragon is quite unusual, as it has evolved feathered wings as opposed to the leathery membranes of other dragons' wings.

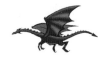

Central and South American Dragon

STAGE 2

Step 1:
Draw an upward curve as the guide for the eyes, a cone on the top of the head, two curves on either side for the cheeks, two curved triangles for the jaws, and a quick, thin line for the tongue.

Step 2:
As you've done before, draw a series of ovals down the centre line; smaller at the neck, getting progressively larger towards the centre of the body and diminishing in size again as you descend towards the tail tip.

Step 3:
Now sketch in a rough design for the tail tip feathers.

Step 4:
Start to lightly shape the ends of the wings, defining the dragon's flight feathers.

Step 5:
Sketch in ovals for the legs, adding circles for the toe joints over your previously drawn toe lines.

Step 6:
Add downward flicks at the ends of the toes to indicate the long, curved claws.

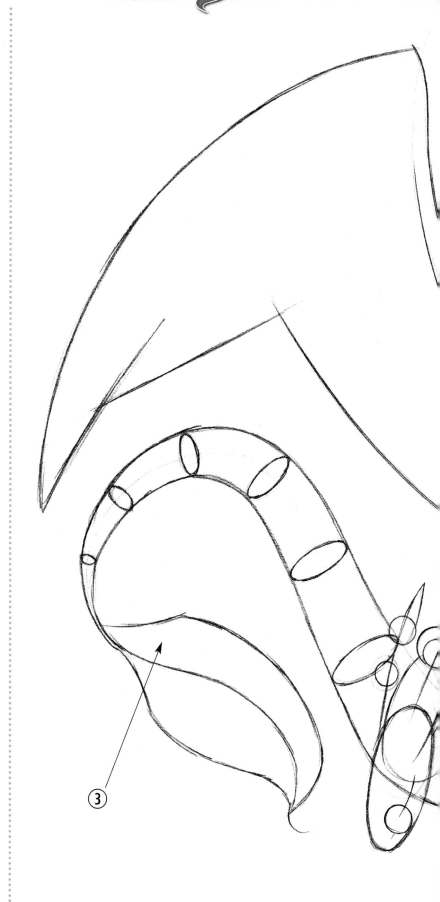

116

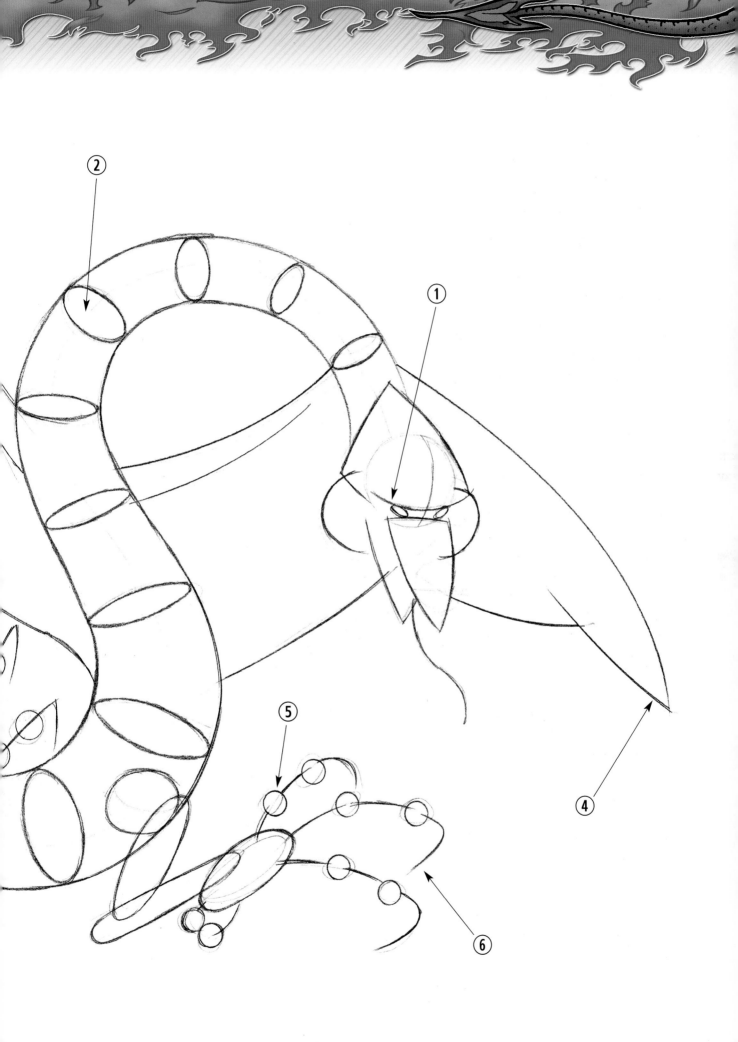

Central and South American Dragon

STAGE 3

Step 1:
Define the upper and lower jaw, mark out the cheek feathers and indicate with curved lines where the crown of head feathers will appear. Add a few quick lines for the eventual eye shape, too.

Step 2:
Once you've joined all the ovals to get the body shape rub them out to leave a cleaner-looking drawing. Next, add guidelines for the feathers inside the wings.

Step 3:
Start to add the individual feathers on the bottoms of the wings, with longer flight feathers at each end.

Step 4:
With fairly straight, angular lines, build up the shape of the tail feathers.

Step 5:
The feet and claws are really taking shape now as you 'flesh' them out, especially the left foot from our worm's eye view vantage point.

Step 6:
By drawing the claws exaggeratedly long and hooked they become very sinister-looking.

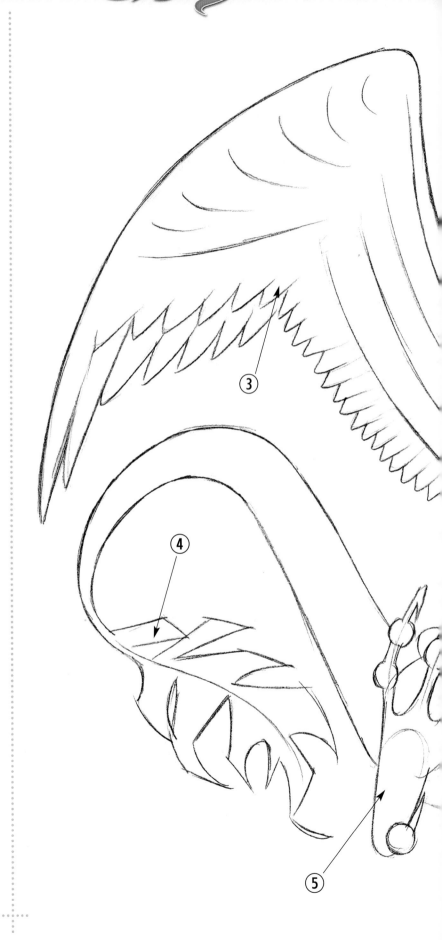

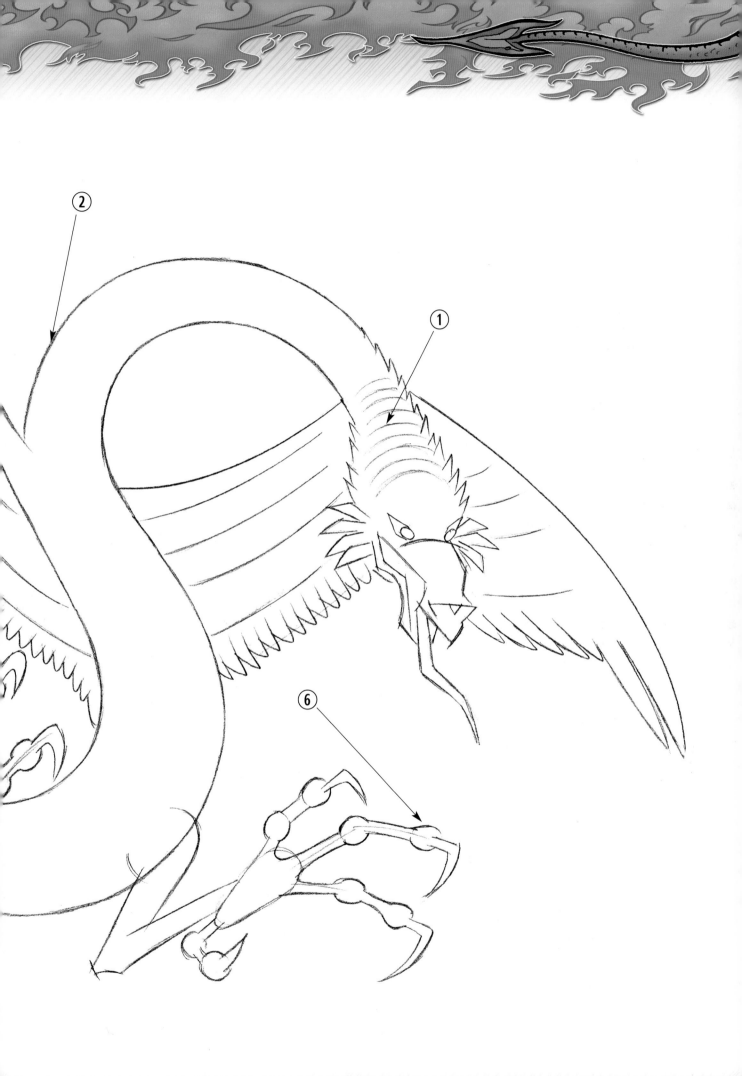

Central and South American Dragon

STAGE 4

Step 1:
Pencil in the individual feathers on the top of the dragon's head. Add the teeth and the nostrils, plus eyelids around the eyes.

Step 2:
Lightly mark out the position of the individual feathers that line the wings. As we're viewing each wing from a different angle, the arrangements of the feathers don't mirror one another.

Step 3:
Add a few light pencil strokes to the tail to indicate the strands of individual feathers.

Step 4:
Build up the legs and feet; think chicken legs while you're drawing these. The Central and South American dragon has evolved quite differently to the Western dragon.

Step 5:
Sketch in the breastplate line and lightly indicate the scale pattern all the way down the body.

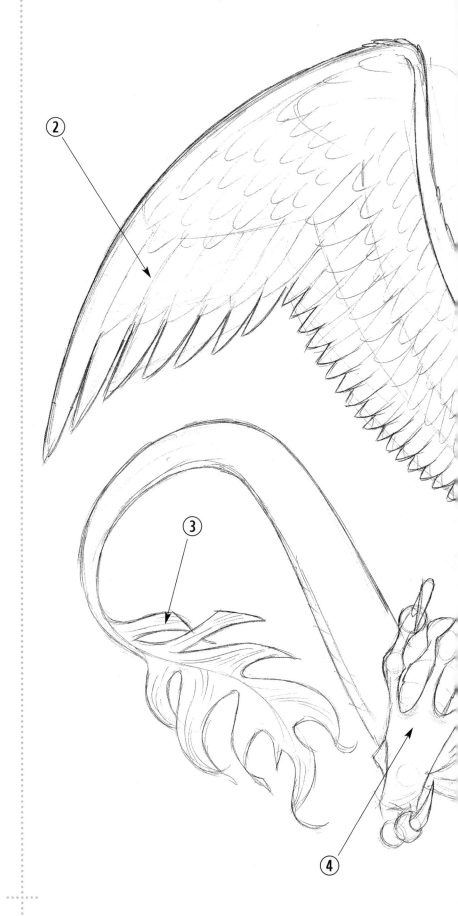

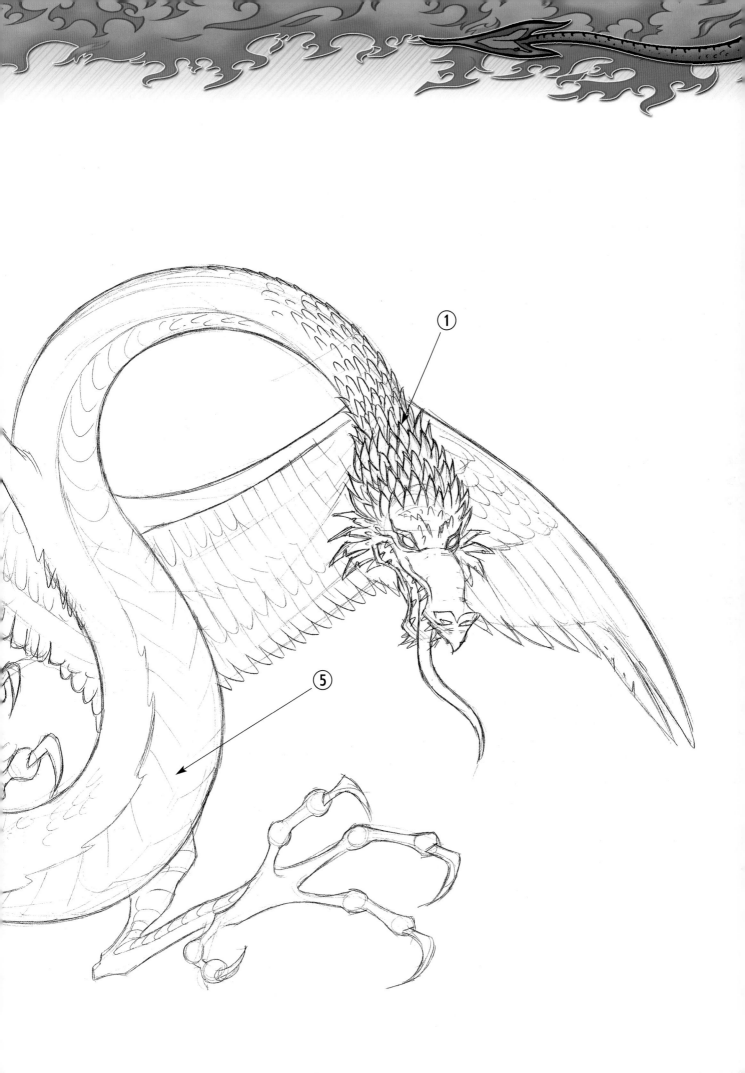

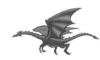

Central and South American Dragon

STAGE 5

Step 1:
The head is now complete. Just darken the stiff, scale-like feathers with your pencil for extra definition.

Step 2:
Pencil in all the feathers on both wings and break up the smooth line on the tops of the wings with some small scales.

Step 3:
Finish off the tail feathers with fine lines, giving the whole area a slight sheen.

Step 4:
Carefully draw in the leathery scales on the bottom of each foot, plus the ones over the top of each leg. Add 'shine' lines to the claws, too.

Step 5:
Finally, add detail to the neck and underbelly scales and – hey presto! – you're ready to start inking.

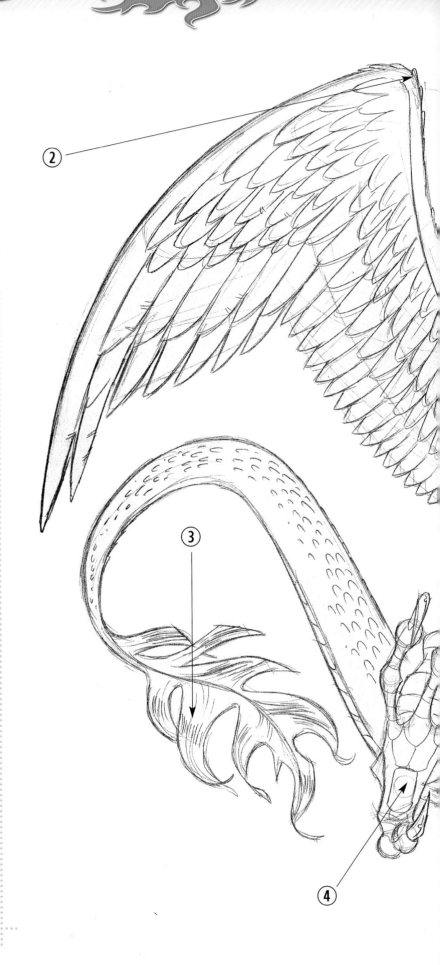

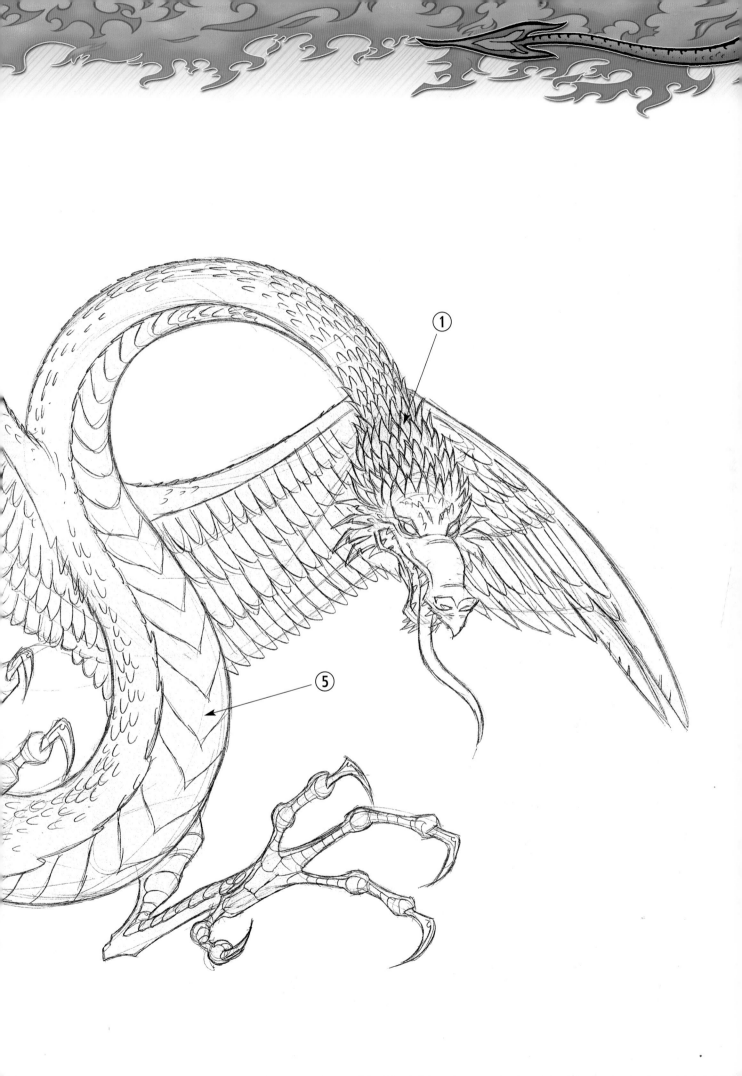

Central and South American Dragon

STAGE 6

Step 1:
Carefully ink in the outline of the head then travel down the neck to the wings.

Step 2:
Using your French curves, ink in the long sweep from the crest of the wing to the elongated flight feathers. With a lighter line fill in all the inner feathers.

Step 3:
With a fine line, ink in the thin lines inside the tail feathers.

Step 4:
The left foot, which is nearer to us, is inked with a heavier line than the right. (Remember, the closer an object is to the viewer, the bolder the line.) Use a fine line again for the scales.

Step 5:
Finally, ink in the breastplates and you're now ready to start colouring.

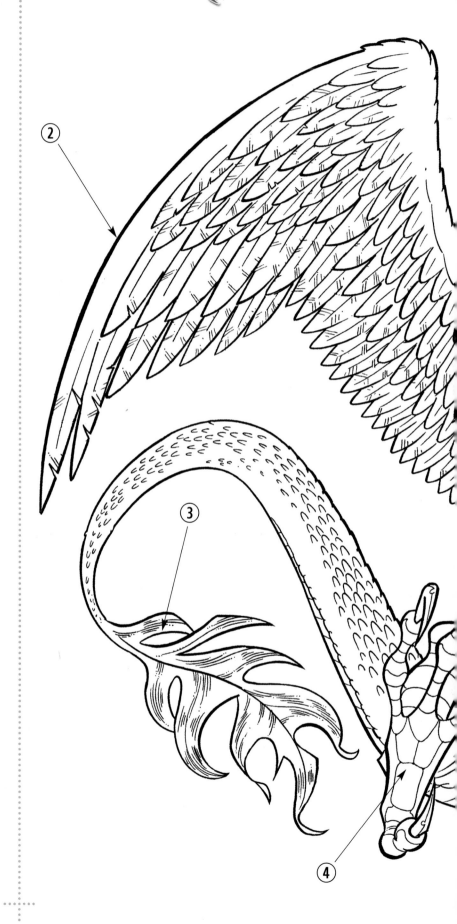

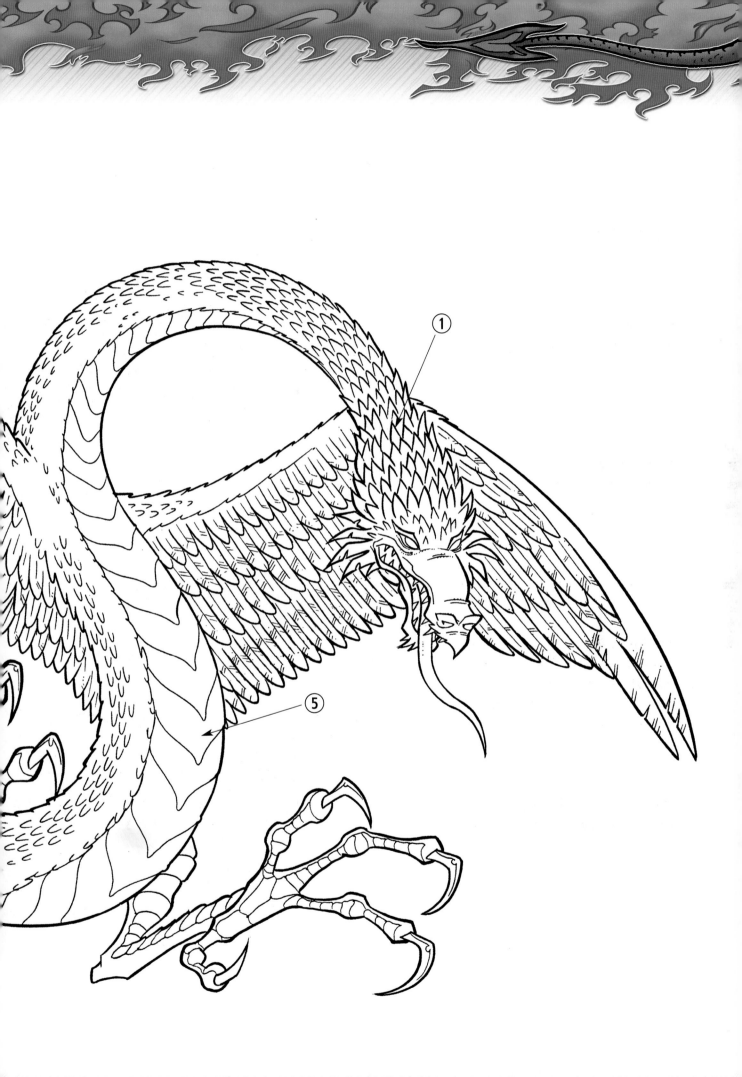

Central and South American Dragon

STAGE 7

Step 1:

The feathers around the side and back of the head are lined with an orange-gold colour, the eyes are a fiery red with yellow pupils, and the long, snake-like tongue is a deep reddish-pink.

Step 2:

The stiff body and wing feathers are a vibrant shade of blue.

Step 3:

The tail feathers are two-toned – a dull gold edging highlights the dark blue.

Step 4:

The underside of the dragon's toes are beige and as hard as dried ox skin. The scales on the upper leg are slightly paler than the rest of the limb colouring.

Step 5:

The long, curved claws are as hard as steel and razor sharp. Once sunk into their prey there's no escape!

Step 6:

The breastplates are a beautiful, shiny, green colour. Apparently, the glossier the scales the more attractive the male is to the female.

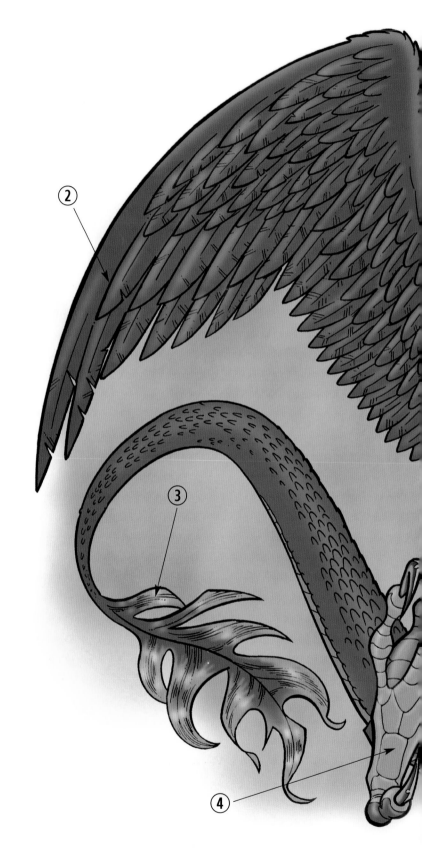

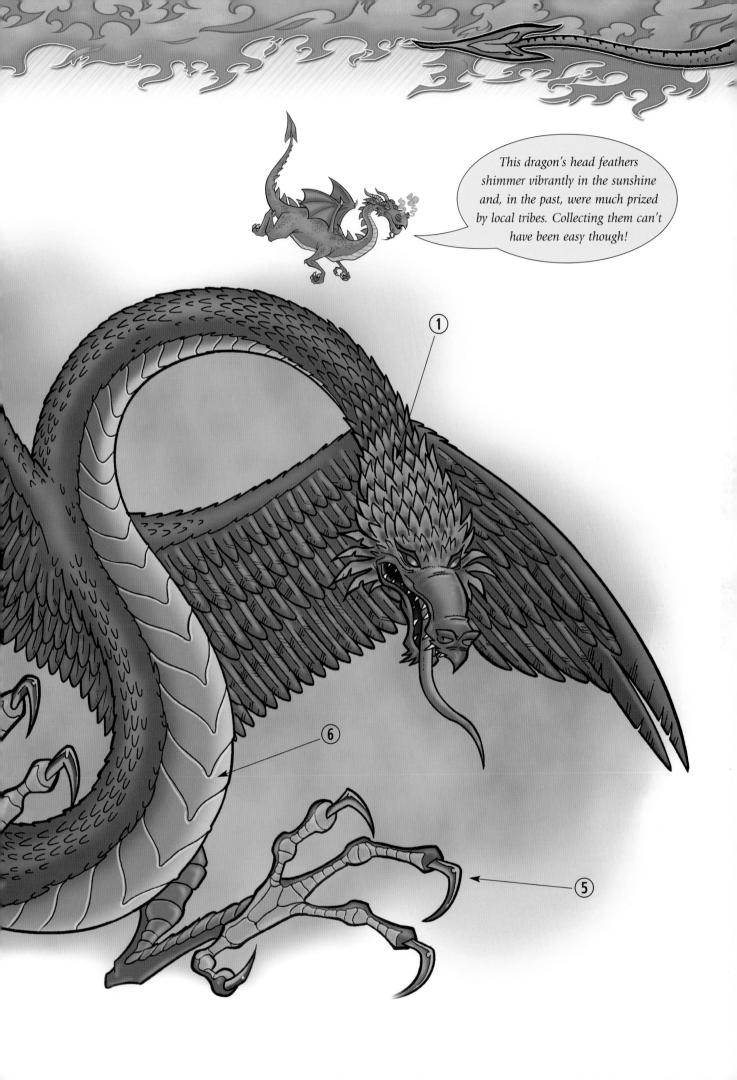

This dragon's head feathers shimmer vibrantly in the sunshine and, in the past, were much prized by local tribes. Collecting them can't have been easy though!

◇African Dragon◇

African Dragon

STAGE 1

Step 1:
Start with the head. Draw a circle for the skull and below this add three different-shaped triangles for the jaws and snout.

Step 2:
Draw the centre line to build your dragon's body on, beginning at the tip of its nose and ending with the very tip of its tail, finishing off with a triangle.

Step 3:
Plan out the wings, using circles to represent the joints in the 'arms'.

Step 4:
The poor, hapless elephant in the dragon's clutches is made up of two circles – one for the head and a larger one for the body – a quick, curved line for the trunk, and stick-like legs. A triangle for the lower jaw and two curved triangles represent the ears.

Step 5:
Mark out the dragon's legs in the usual way and sketch in ovals for the feet.

The African Dragon (Draco Africanus) – or wyvern – is the largest of all the dragons and, by its very nature, the most feared.

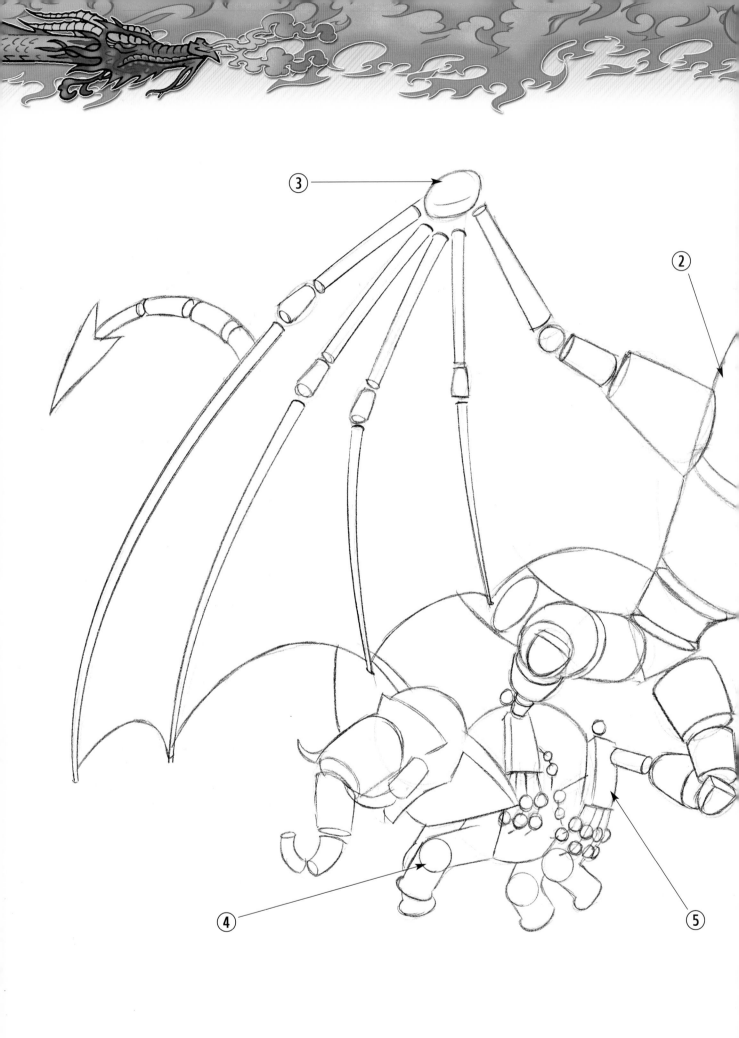

African Dragon

STAGE 2

Step 1:
Construct the head using angular lines, as though it's made up of building blocks. Don't forget to add the horns.

Step 2:
The torso is made up of cylinders, the largest being the chest cavity and the smallest the waist. The wing 'arms' should be constructed the same way.

Step 3:
Draw two ovals at the tops of the wings, which will be the anchor-points for the 'fingers', enabling the wings to splay out. Add cylinders for the 'knuckles', and long, tapering tubes for the fingers.

Step 4:
The same technique is used to build up the elephant. Enlarge the circles for its knees and add tusks to the cheeks.

Step 5:
Draw cylinders for the dragon's legs and a couple of flat blocks for the feet. Use little balls joined by thin lines for the toe knuckles, and curve the feet around the elephant's body.

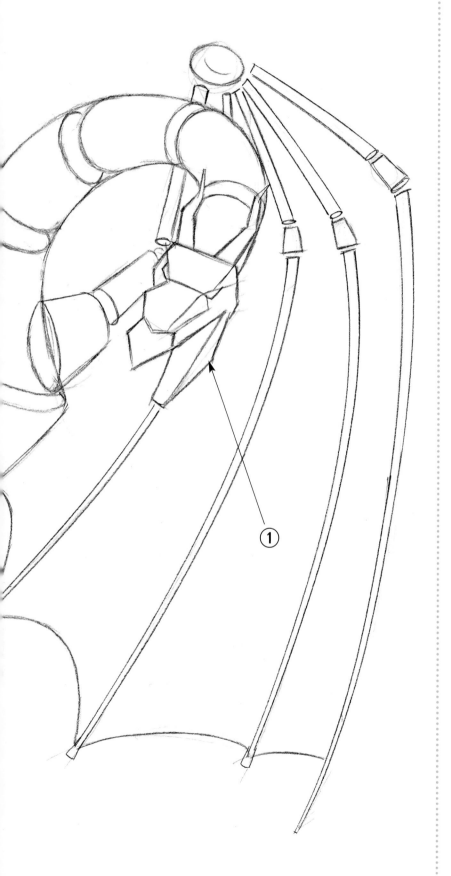

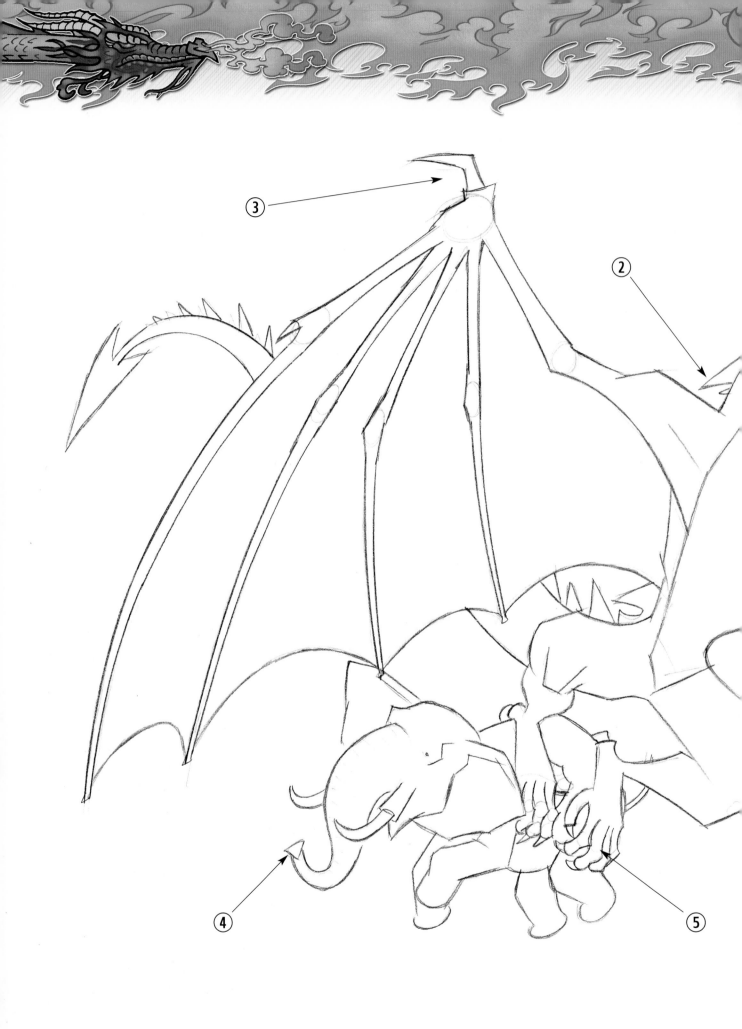

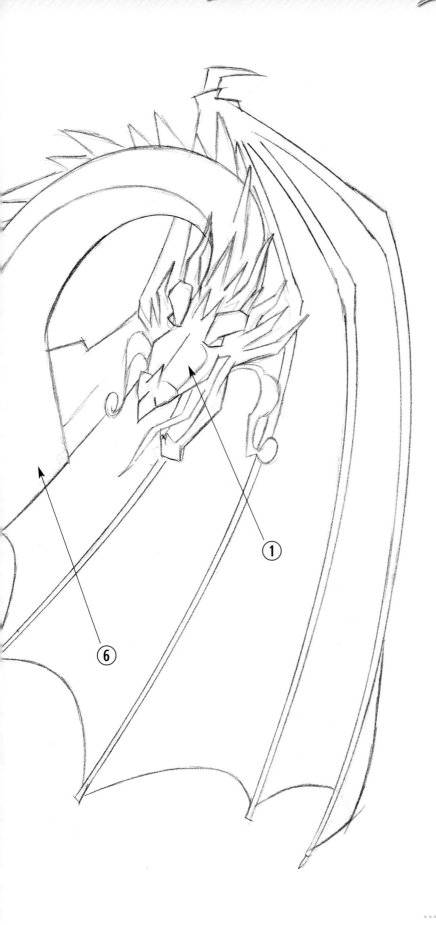

African Dragon

STAGE 3

Step 1:
All the head details are now roughly sketched in: the cheek spikes, the nose horns and the skin flaps on the lower jaw, not forgetting the shapes where the eyes scales will feature.

Step 2:
Draw sharp, triangular spines down the back of the neck and all the way along to the tip of the tail.

Step 3:
Build up the shoulder muscles, arms and fingers of the wings with angular lines. Draw two large, vicious-looking claws at the crest of each wing.

Step 4:
Build up your elephant, drawing a dot for the eye, a small triangle at the end of his trunk and giving more definition to the ears.

Step 5:
Fill in the toes and add the claws. Shape up the legs using the same sharp, angular lines you used in Step 3.

Step 6:
Draw in the shape where the neck and breast scales will appear later.

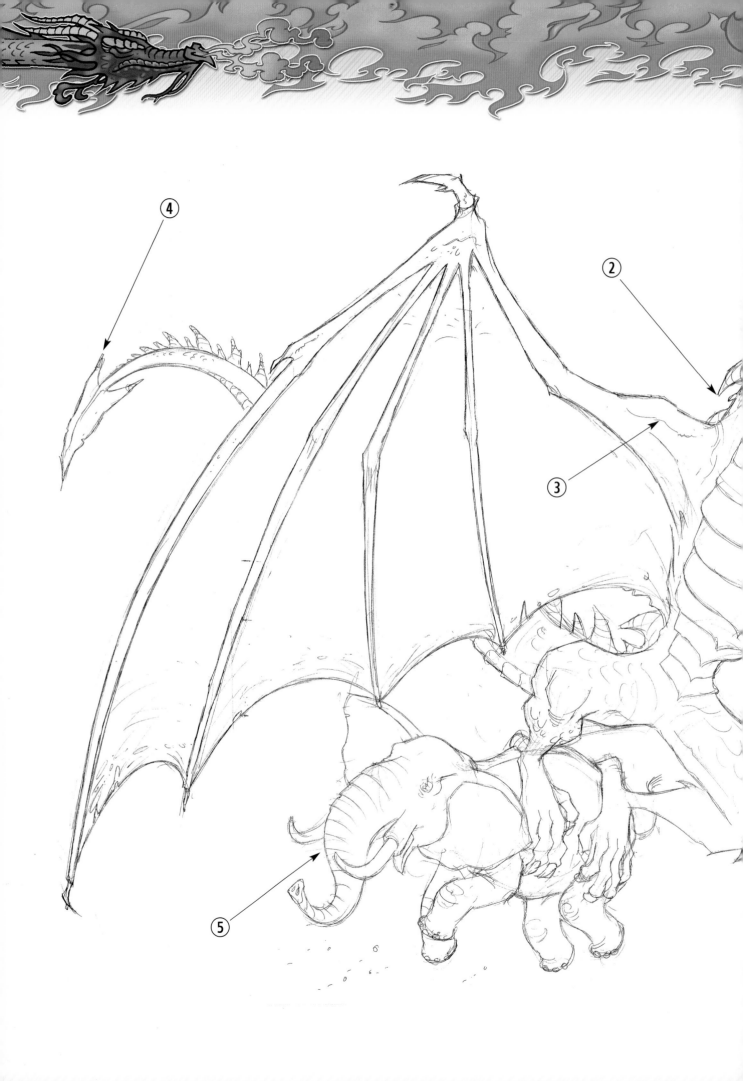

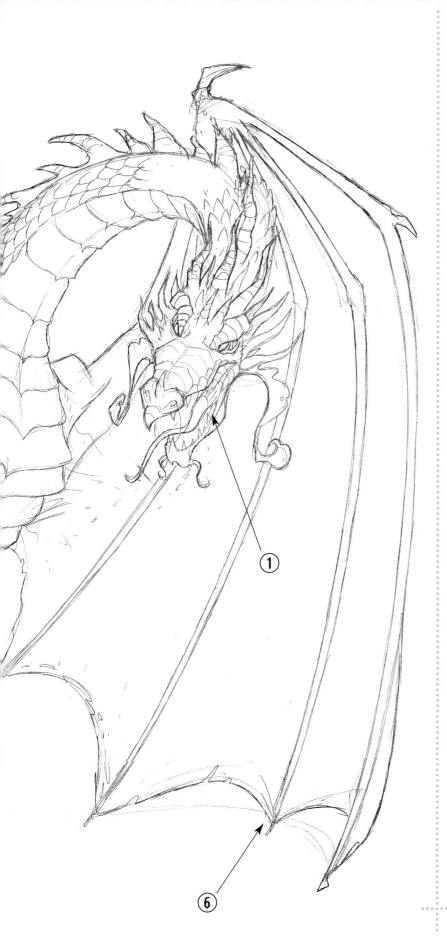

African Dragon

STAGE 4

Step 1:
Now pencil in more carefully the ridges over the eyes and those on the horns, the teeth, and the flaps of skin from the lower jaw.

Step 2:
Build up the dragon's body, smoothing off the sharp, angular lines and defining the plates that run down the back. Lightly sketch in the scales.

Step 3:
Sketch in the lines indicating the muscles in the shoulders, and add a few little extra spikes to the large hooks on the wings.

Step 4:
Shape the spear-like tip at the end of the tail, adding two bony horns on each of the two points at the back of it.

Step 5:
Lightly draw in the ridges on the elephant's trunk and mark in its toenails.

Step 6:
Indicate the stretch marks on the membrane between the fingers of the wings, and add little claws to the tip of each one.

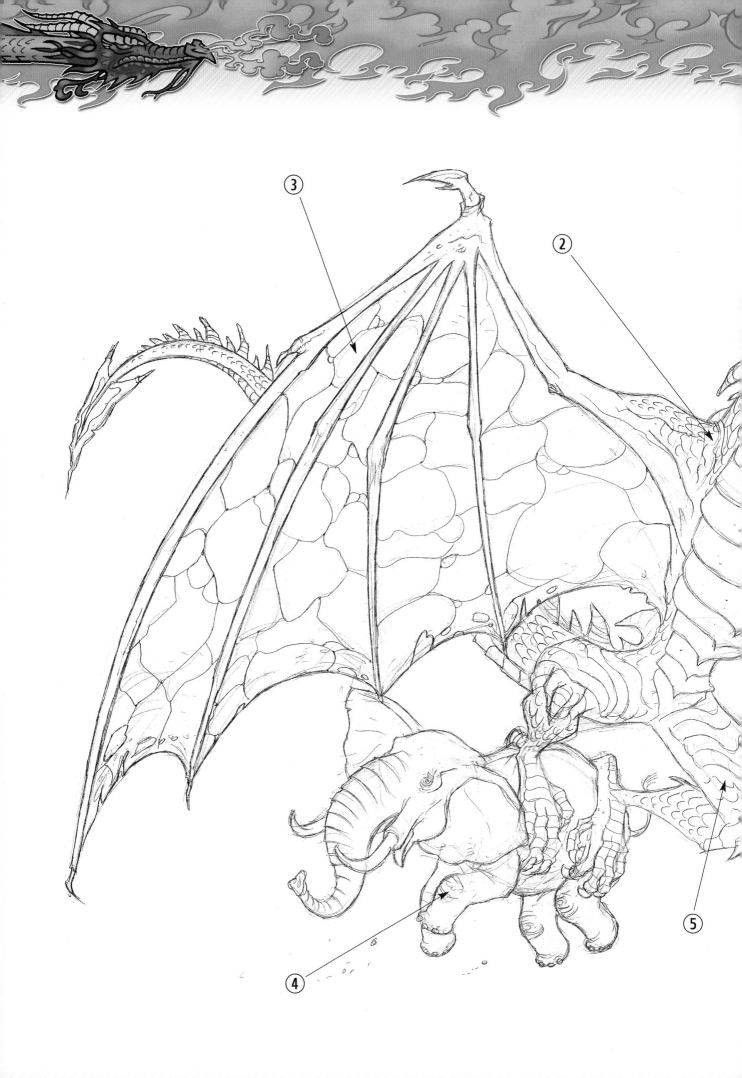

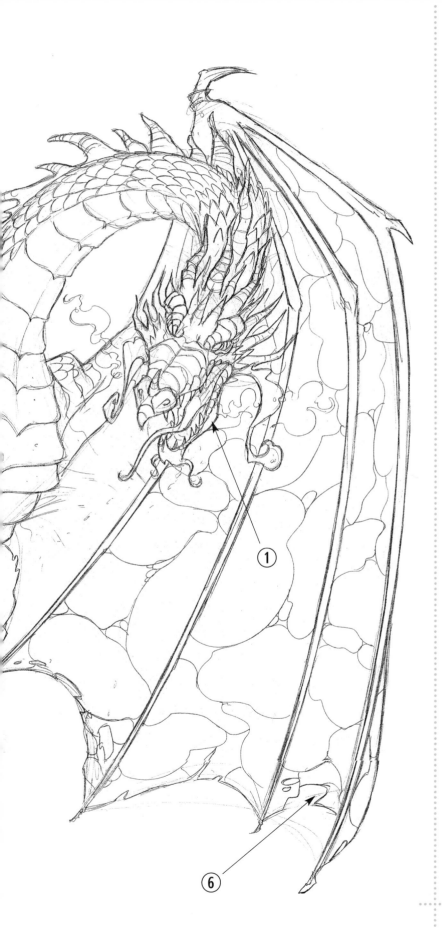

African Dragon

STAGE 5

Step 1:
Now completely fill in all the details for the head, adding folds of skin under the eyes, scales around the jaws and some wisps of smoke escaping from the jaws.

Step 2:
Cover the whole upper body with armour-like, spear-tipped scales. They travel a little way over the shoulders too, but fade out once they reach the arms.

Step 3:
Draw in the pattern on the wing membranes created by the dragon's blood vessels flowing through its massive wings.

Step 4:
Add little details to the elephant, such as wrinkles around the eyes and knees.

Step 5:
Draw overlapping plates of iron-hard skin on the thighs, feet and toes, and two hooks protruding from the kneecaps to give the dragon extra armoury.

Step 6:
Add holes and a bit of wear and tear to the bottom of the wings.

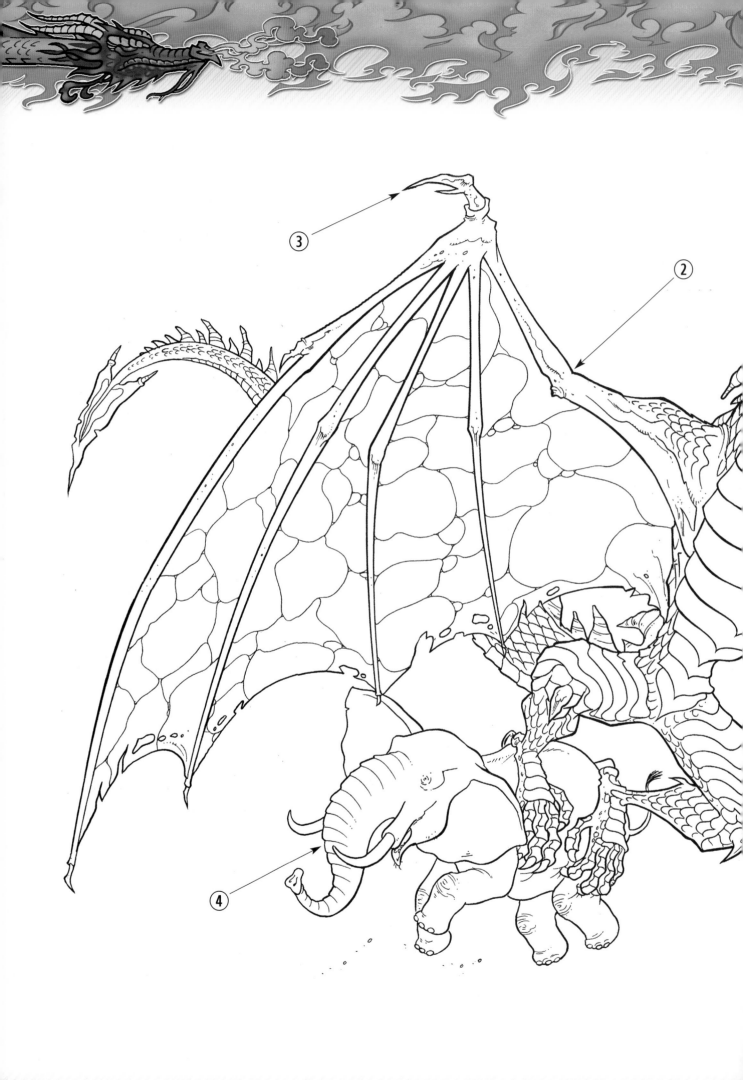

African Dragon

STAGE 6

Step 1:
When inking, it's often best to start with the eyes; one always focuses on the head first and the eyes in particular. Once these are complete, ink in the rest of the body from the head down using a bold line.

Step 2:
Next, work on the left wing, moving over to the right when that's completed. Those French curves are very handy indeed for the outer edges of the wings, not to mention the 'fingers' sweeping down.

Step 3:
Ink in the claws on top of the wings.

Step 4:
Now move on to the elephant.

Step 5:
Finally, with a finer line, dip pen or felt-tip, ink in all the more delicate lines: the wrinkles and scales on the face, all the scales that cover the body and, of course, the network of veins covering the leathery wing membranes. Don't forget the knee-wrinkles of the soon-to-be-devoured elephant. Well, a dragon's gotta eat!

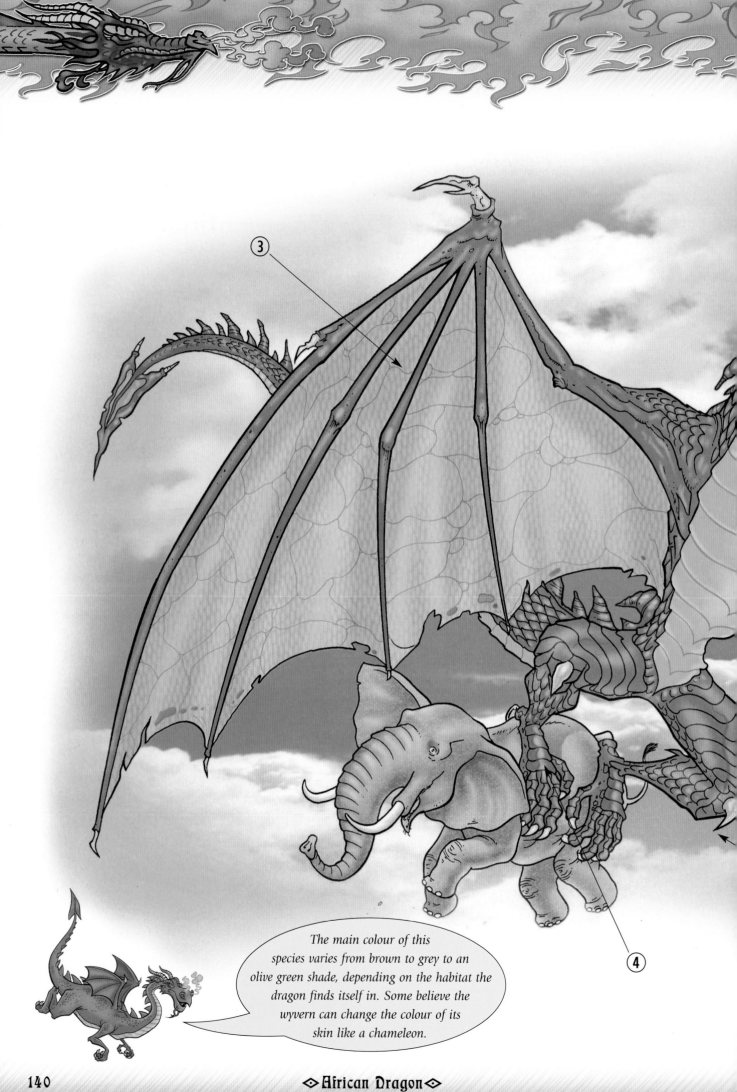

The main colour of this species varies from brown to grey to an olive green shade, depending on the habitat the dragon finds itself in. Some believe the wyvern can change the colour of its skin like a chameleon.

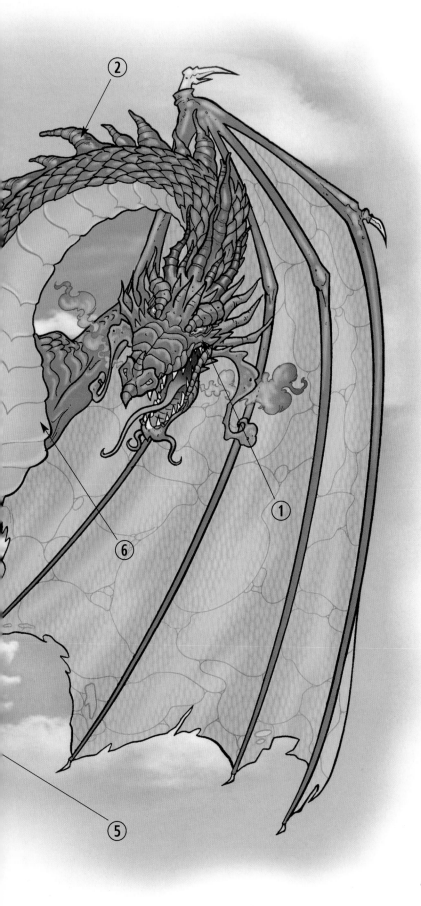

African Dragon

STAGE 7

Step 1:
The head and body of this huge dragon is more or less a uniform brown-grey. The horns are a deep blue-black, while the yellow, bloodshot eyes glow with malice.

Step 2:
The vicious spines that snake down from the top of the head to the spear-shaped tail tip are the colour of rich, African soil.

Step 3:
The mottled wings are filled with a network of veins flowing with the surprisingly yellow blood that some dragons have.

Step 4:
The plated scales on the top of the feet are the same reddish earth colour as the spines.

Step 5:
The two knee-claws are pale – almost the colour of pearls – as are the talons and all the claws featured on the wings.

Step 6:
The large breastplate running down the neck to the lower belly are said to be ivory.

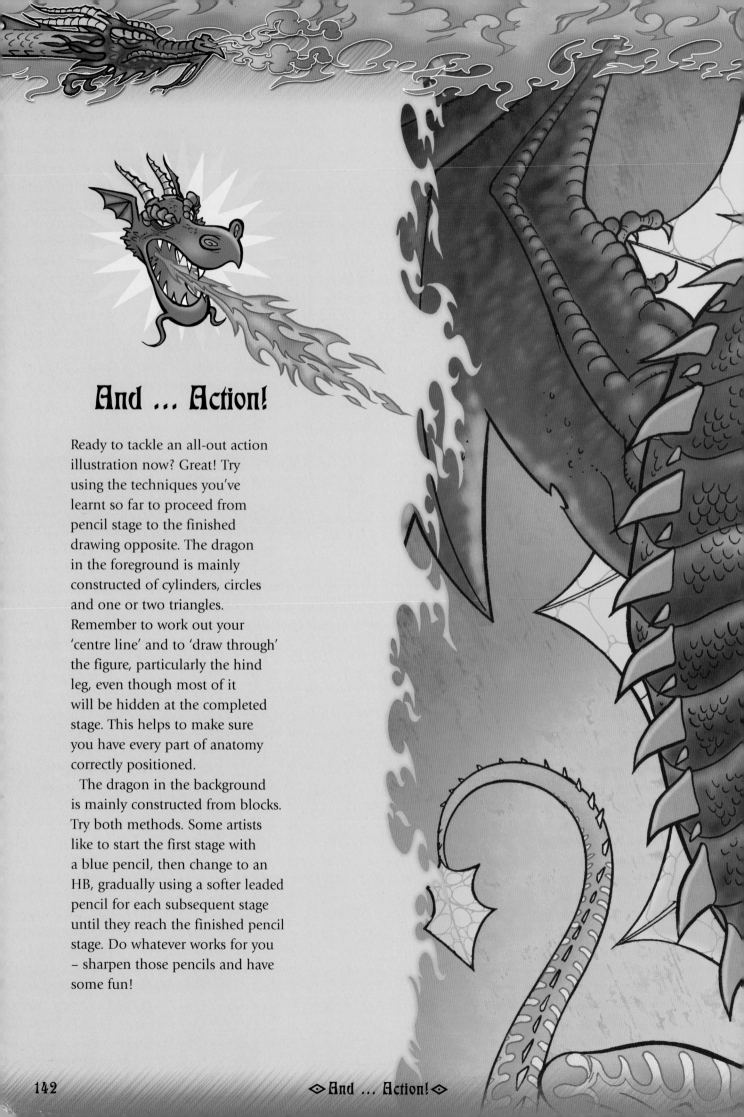

And ... Action!

Ready to tackle an all-out action illustration now? Great! Try using the techniques you've learnt so far to proceed from pencil stage to the finished drawing opposite. The dragon in the foreground is mainly constructed of cylinders, circles and one or two triangles. Remember to work out your 'centre line' and to 'draw through' the figure, particularly the hind leg, even though most of it will be hidden at the completed stage. This helps to make sure you have every part of anatomy correctly positioned.

The dragon in the background is mainly constructed from blocks. Try both methods. Some artists like to start the first stage with a blue pencil, then change to an HB, gradually using a softer leaded pencil for each subsequent stage until they reach the finished pencil stage. Do whatever works for you – sharpen those pencils and have some fun!

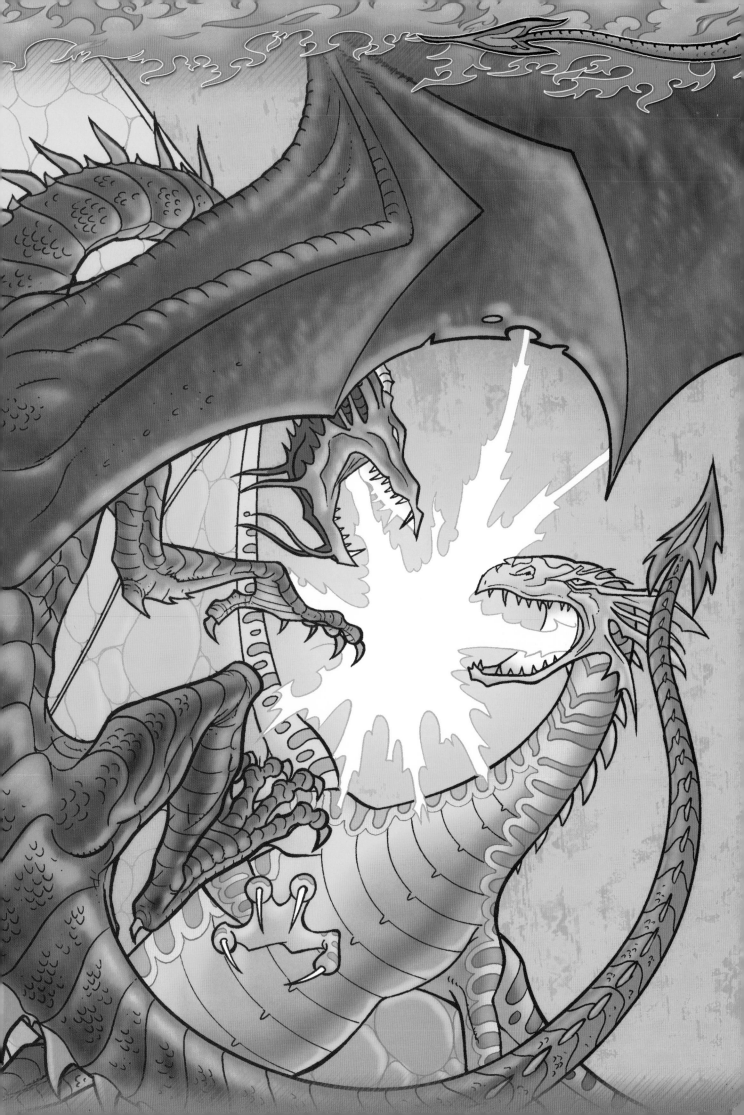

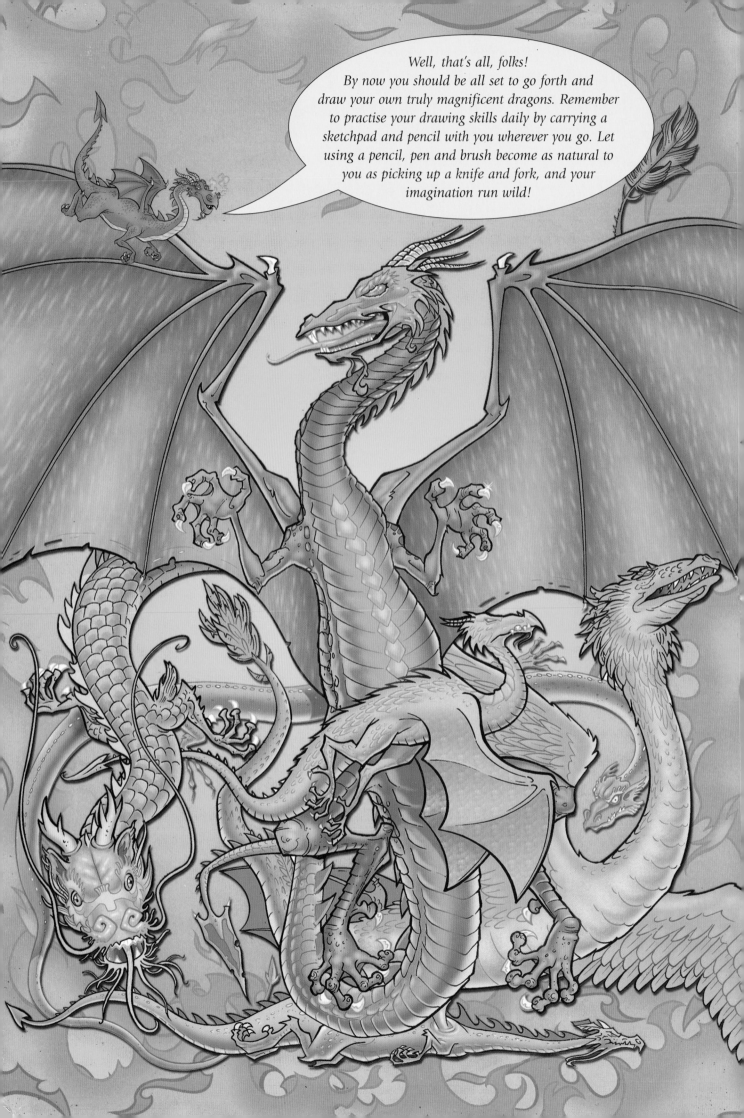